DOVER
THROUGH TIME
Robert Turcan

AMBERLEY PUBLISHING

First published 2010

Amberley Publishing
Cirencester Road, Chalford,
Stroud, Gloucestershire, GL6 8PE

www.amberley-books.com

Copyright © Robert Turcan, 2010

The right of Robert Turcan to be identified as the
Author of this work has been asserted in accordance
with the Copyrights, Designs and Patents Act 1988.

ISBN 978 1 4456 0005 5

British Library Cataloguing in Publication Data.
A catalogue record for this book is available from
the British Library.

Typeset in 9.5pt on 12pt Celeste.
Typesetting by Amberley Publishing.
Printed in the UK.

Introduction

Geography has governed Dover's history, and history its appearance. It confronts Continental Europe with its impregnable castle raised as a snub nose in defiance. This town's *raison d'être* as a gateway to foreign places and a conduit for other races is renowned. So too is the visage of its white cliffs, forever sentimentalised by Vera Lyn's nostalgic wartime song.

Earliest remains of human settlement at Dover include a Bronze Age boat which was used for crossing Channel trade. The Romans had a major port here and built two lighthouses on the cliffs high above town to aid navigation. Following the Norman invasion a huge castle was developed on an old site on the eastern cliff. Its expansion during the reign of Henry II made it impregnable despite a major attack by French forces in the thirteenth century.

Many royal personages and important diplomats travelled through Dover during the middle ages and later periods. Pilgrims to Thomas Becket's shrine at Canterbury Cathedral passed on their journeys from the continent.

The town's significance to the defences of England was firmly established when it became the premier Cinque Port. These were set-up to provide fighting ships and crews in the event of war. In return the five coastal towns were exempted from national taxes and became largely self governing.

As the old harbour, first used by Romans, silted up, the docks moved to the western side of Dover. London was a day's journey away and so many continental travellers stayed in the town awaiting a favourable wind to take them to France. Many inns and hotels sprang up to serve this trade and since then it has become a major local business. By regency times sea bathing had become a fashionable pastime, and Dover developed into a resort. In the mid-Victorian age, bathing machines lined the beach, palatial hotels jostled along the front and a general air of prosperity prevailed.

Defensive installations and vast army barracks were constructed throughout the nineteenth century. Threats from France were at their height during the Napoleonic wars. However, later scares in the 1850s prompted extensive excavation of tunnels and fortifications.

Two cross Channel pioneers in the Edwardian era put Dover on the map. Bleriot was the first pilot to fly across from France in 1909, and then Charles Rolls did it both ways without stopping a year later. These aviators' feats are commemorated with statues and memorial plaques.

When the First World War began in 1914, Dover Harbour was already a major Royal Navy port. The harbour walls enclosed a square mile of protected water – sufficient to hold a large fleet at anchor. A flying boat station was established and pens to hold submarines. However, its main function was as an embarkation station for the thousands of soldiers serving on the battlefields of France and Belgium.

Again in the Second World War Dover, or hellfire corner as it was known, was to play a major role. The evacuation of Dunkirk was directed by Vice Admiral Ramsey in naval headquarters below Dover Castle. Operation Dynamo was named after the Dynamo Room, where they worked beneath the cliffs. Seven hundred civilian boats took part in saving over 300,000 troops fleeing German forces. Later in 1940, the Battle of Britain was fought over the skies of south-east England. Dover was badly damaged by aerial bombardment as the Germans tried to knock out radar pylons and naval installations. The population of Dover used the many tunnels in the cliffs to shelter from the Luftwaffe. However, Dover survived, but much of the palatial hotels and grand terraces along the front were destroyed. When D-Day was planned, an operation of deception was organised to mask the actual focus of Overlord, known as Fortitude South. Around Dover the fields were dotted with inflated dummy tanks, lorries and planes. Meanwhile the harbour was crowded with imitation landing craft.

After the war major reconstruction was necessary and the Gateway flats were built to fulfil this need. The roll-on ferry port expanded with the demand for foreign holidays and growing European trade. Today Dover is one of the busiest ports in the world, but it retains its sense of history. Its white cliffs and castle are forever beacons of hope and freedom to this proud nation. The images in this book illustrate how Dover has adapted to the needs of ever changing times.

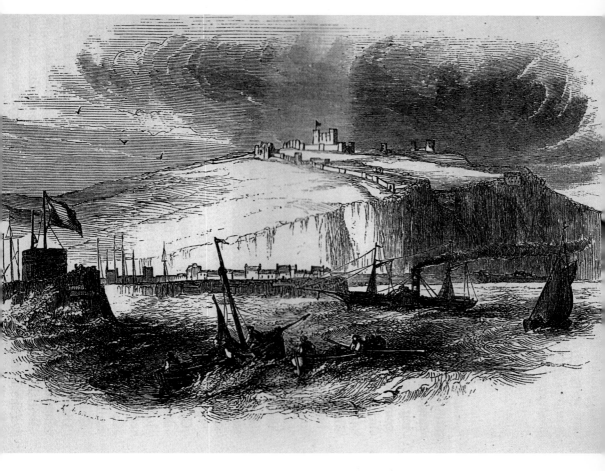

A mid-Victorian seascapes print of Dover Harbour taken from *Blacks Guide to Kent*.

How stands the old Lord Warden?
Are Dover's cliffs still white ...

Rudyard Kipling – the last line from *The Broken Men*

To Neels Borman – the best of friends.

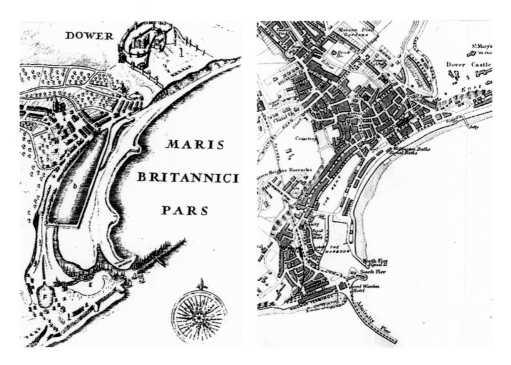

Dover's Development over the Centuries

These maps illustrate the growth of Dover and in particular its harbour. The first map is from the sixteenth century while the second one is from mid-Victorian times. The last map from the 1920s shows Dover Harbour complete, enclosing, roughly, a square mile of sea.

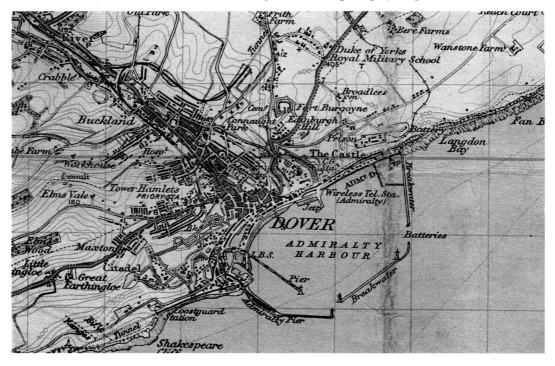

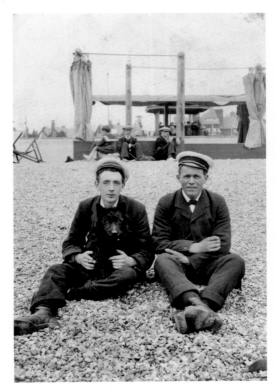

With My Dog at Dover
The sepia pre-war picture to the right shows two ship's stewards relaxing while off duty, with their Scottie. Below is a snapshot of entrants in the Newfoundland parade at the 2010 Dover Regatta.

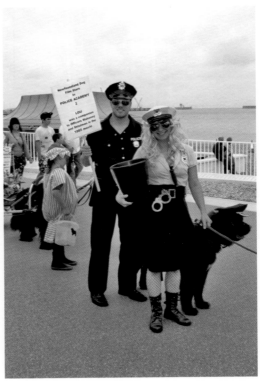

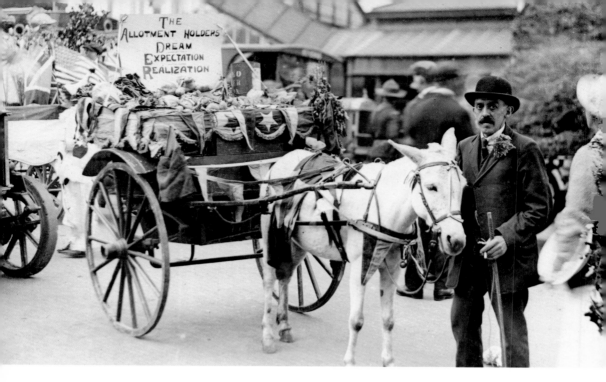

Carnival Parades

The old sepia image shows an entrant to Dover carnival in the interwar years. Below is a scene from the 2010 Dover regatta. The Newfoundland dogs follow their display of life saving at sea with a fancy dress show.

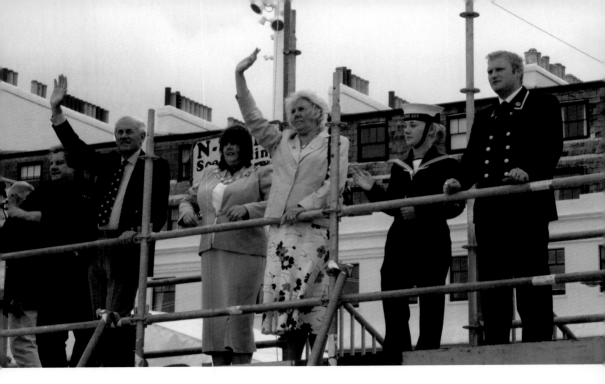

Lord Warden of the Cinque Ports

In 1904, Earl Curzon of Keddlestone was installed as Lord Warden of the Cinque Ports. As Viceroy of India 1898-1905, he was well accustomed to pomp and ceremony. More recent incumbents have included Sir Winston Churchill, Earl Mountbatten and Queen Elizabeth the Queen Mother. Present holder of this ancient title is Admiral Lord Boyce who is photographed above waving to boats at Dover regatta. As a sinecure and honorary title his duties are purely ceremonial, but the original post dating from the twelfth century was to be in charge of five key South Coast ports, including Dover.

'Bowling'

Dover Bowling Club can be found today at Maison Dieu Gardens, but a new kind of fun using human bowls was on show at the beach during the regatta celebrations.

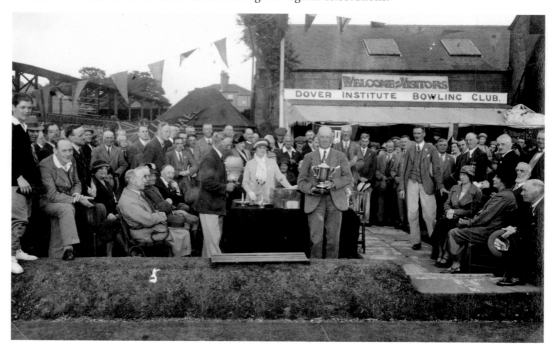

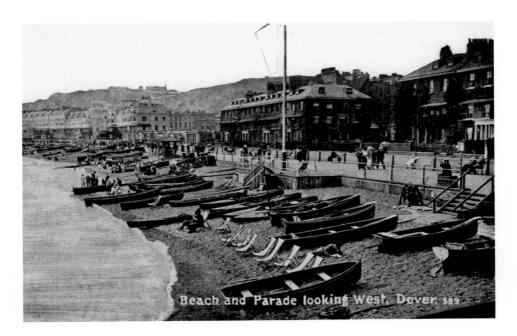

Beach and Parade looking West, Dover. 589

Beach Recreations

In the picture above a group of rowing boats rest on the beach awaiting their sporting occupants. Many years later at the same place there was a display of Newfoundland rescue dogs at Dover regatta. These animals are strong swimmers due to their huge muscles, webbed feet and waterproof coats. One is reputed to have saved Napoleon from drowning during his escape from Elba. Also Lord Byron wrote a moving poem to his departed Newfoundland. He is associated with Dover, where he stayed occasionally, by his ode to the poet Churchill, who was buried in a Dover churchyard.

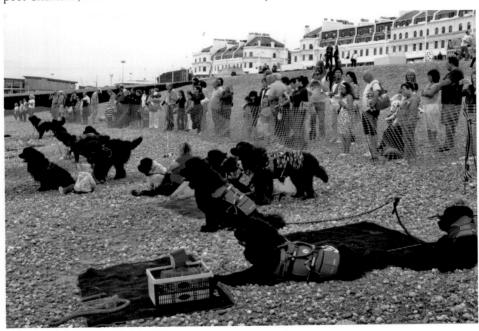

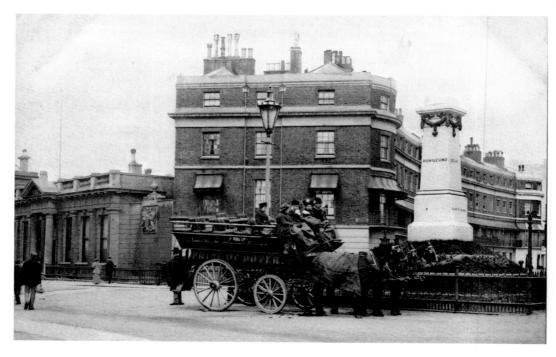

Monument Square

Erected just back from the promenade is an elegant monument to soldiers who fell during the Indian Mutiny of the 1850s. It once served as a stopping place for an open horse-drawn bus called the *Pride of Dover*. Now the memorial has lost its railings, but has gained colourful municipal bedding plants and the cars parked nearby are called multi-purpose vehicles.

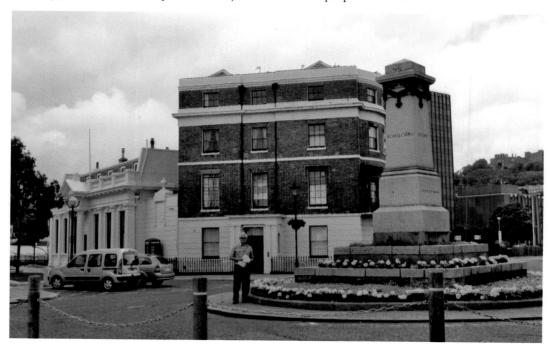

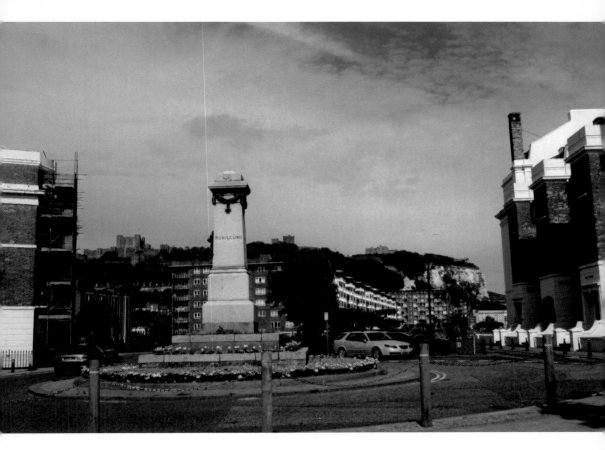

Literary Associations of Camden Crescent

It was at 10 Camden Crescent that Charles Dickens read *Bleak House*, his latest creation, to Wilkie Collins and Augustus Egg. Just around the corner in Marine Parade, Henry James lodged in 1884. While staying here he wrote the first part of *The Bostonians*. Byron's last days in England were spent nearby while he waited for a more favourable wind to remove him from his creditors.

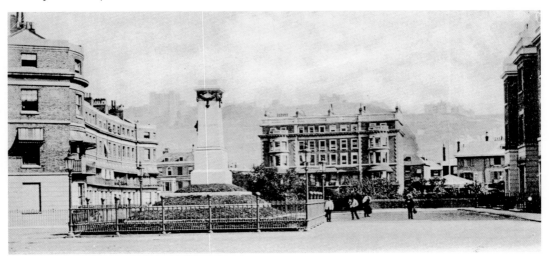

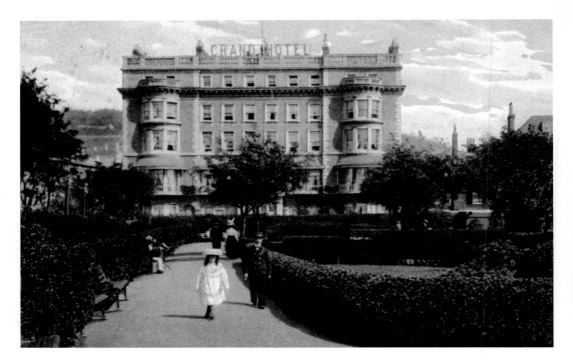

Splendid Hotels of a Century Ago

Established in 1893 from a converted terrace of early Victorian houses, the Grand Hotel was beautifully sited by Granville Gardens and the seafront. In the picture above, taken in 1905, its bourgeois dignity can be fully appreciated. Sadly, as a prominent target for enemy action in the Second World War it was destroyed. The golden Edwardian age with its typical accessories such as *jardinières* and dark mirrored over mantles is further illustrated below by an interior picture of the Metropole Hotel (now the Eight Bells public house in Cannon Street).

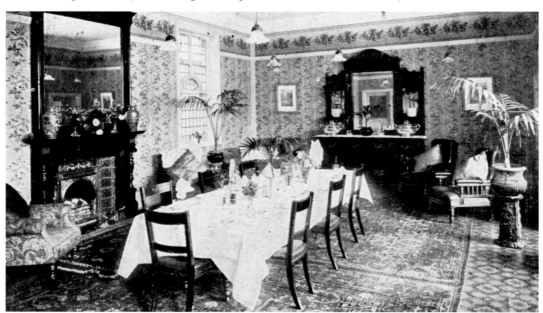

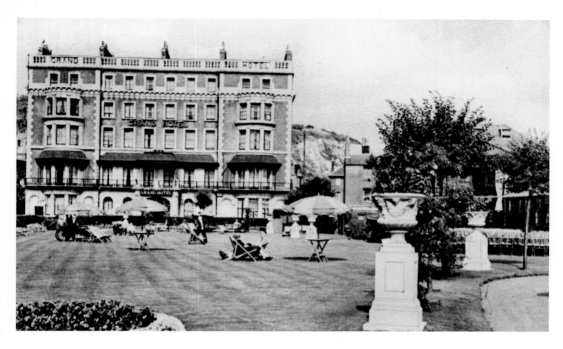

Grand Hotel
The Grand Hotel was the headquarters of many foreign journalists in the Second World War. It was later destroyed by a bomb in 1940.

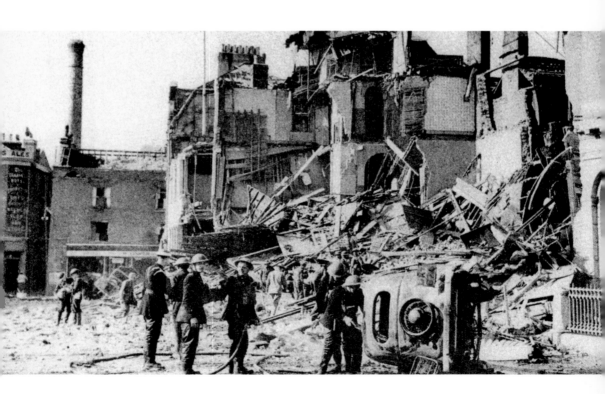

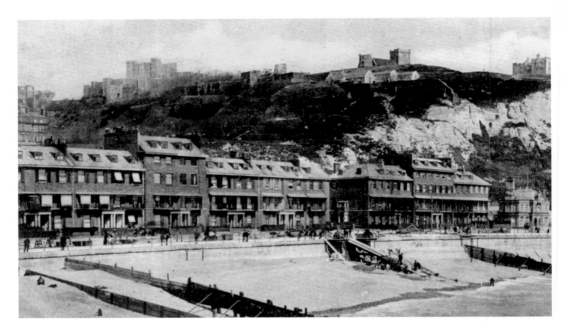

Marine Parade

Once an open area used for a ropewalk to make ships ropes, Marine Parade was developed in 1816 by the Harbour Commissioners. Completed in 1820, the buildings were so badly damaged by enemy action in the Second World War that the site was cleared for redevelopment. In the late 1950s, Gateway Flats arose under the instructions of the local authority. Unfortunately the scale and design of this scheme does not pleasingly blend into its location.

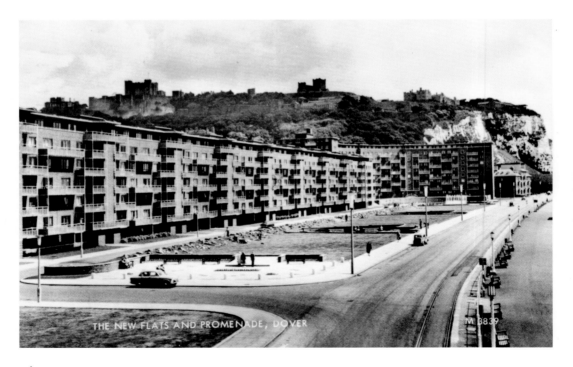

THE NEW FLATS AND PROMENADE, DOVER

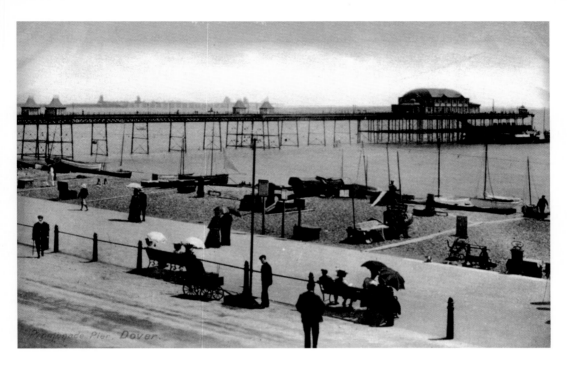

Dover Promenade Pier
Dover Promenade Pier had a short life. It was designed and built by J. J. Webster in 1893 and demolished in 1927. In the pavilion, concerts and skating were staged while the Navy used its length as a landing facility during the First World War.

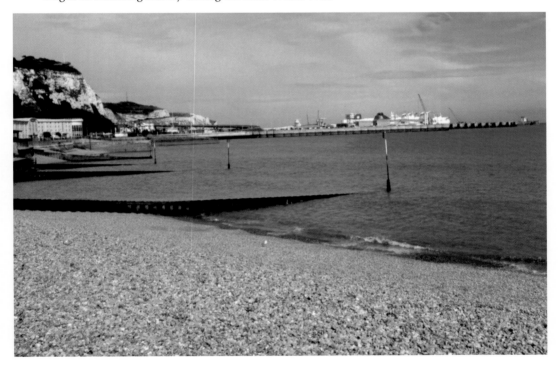

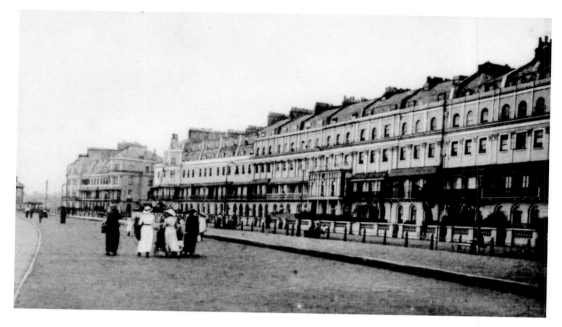

Waterloo Crescent

Architectural and sartorial elegance combine here to portray grandeur of life before the clatter and fumes of a motor car age. This beautiful crescent facing the sea was built by Philip Hardwick in 1834-38. The central section contained nineteen houses, with five outward facing houses either side. All the dwellings had five storeys with basements. In Victorian times Lambert Western and Son, photographers to the Queen and HRH Prince Arthur, had premises at No. 18.

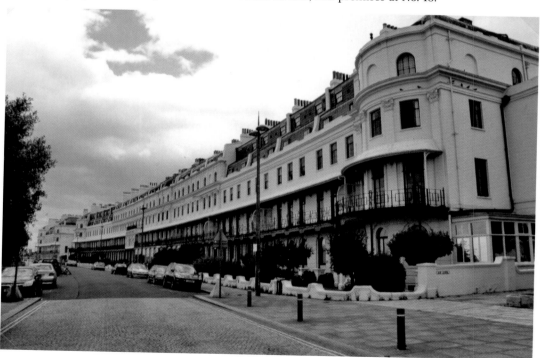

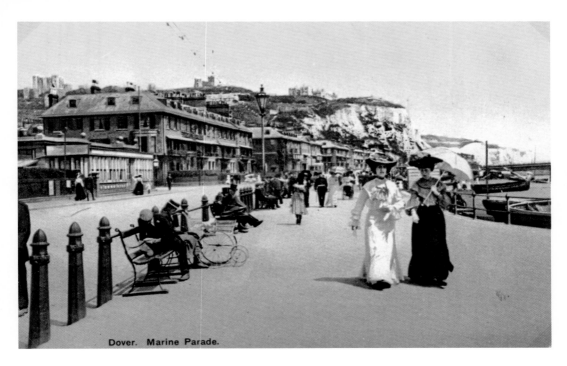

Dover. Marine Parade.

Fashionable Seaside Resort

These Edwardian postcards illustrate the elegance and beauty of Dover as a seaside resort. From early Victorian times holiday makers stayed here rather than just travelling through to other destinations. Presently, with high speed trains making the journey to London much quicker, a revival is expected. There are extensive plans for new housing developments to cater for an influx of metropolitan settlers or holiday homes.

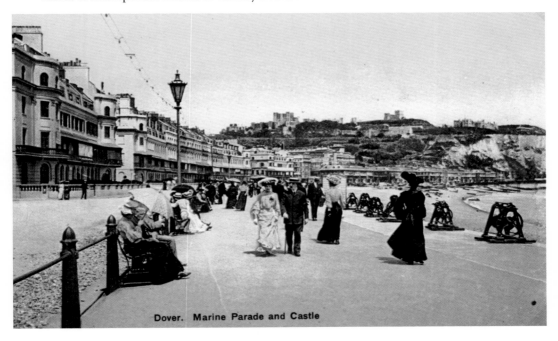

Dover. Marine Parade and Castle

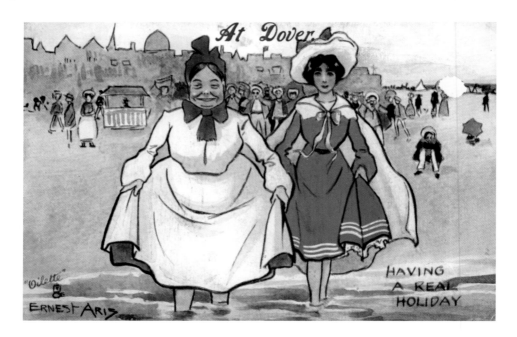

Bathing Machines

Legal separation of bathing areas between men and women ended in 1901 and by 1920 bathing machines had declined rapidly. Men were allowed to swim nude until the 1860s. However, the bathing machine was a boon, mainly to women who had a rigorously modest bathing etiquette. They entered these contraptions in their normal clothes which in privacy they changed out of and maybe into a costume of, by modern standards, unrevealing nature. A horse would back the vehicle into the sea and the occupant could then descend steps into the briny unobserved. When the customer wished to be withdrawn from the waves they could hoist a flag signal to the operator on the beach to conclude this considerable palaver.

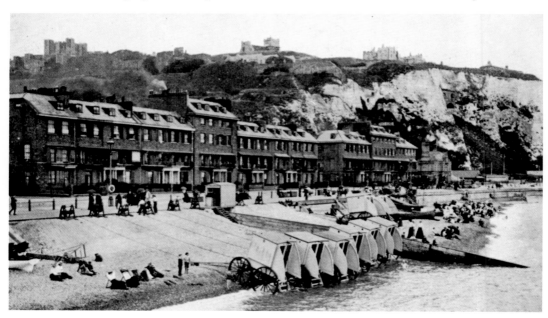

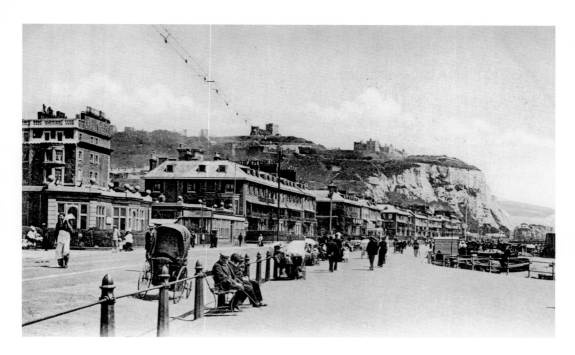

East Parade

East Parade suffered appalling damage during enemy bombardment in the Second World War. Its badly oversized replacement is reminiscent of a Moscow suburb. However, inside the Parade's almost endless exterior there are many charming homes with wonderful panoramic views of the glistening Channel.

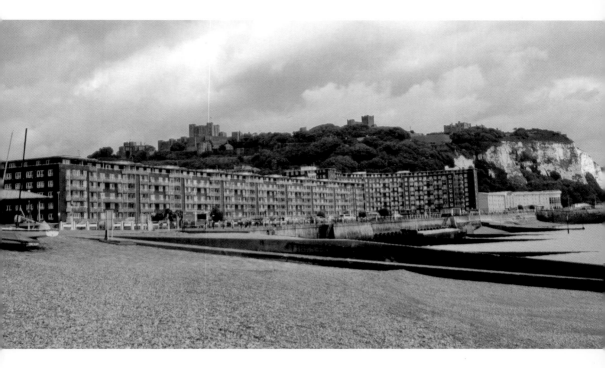

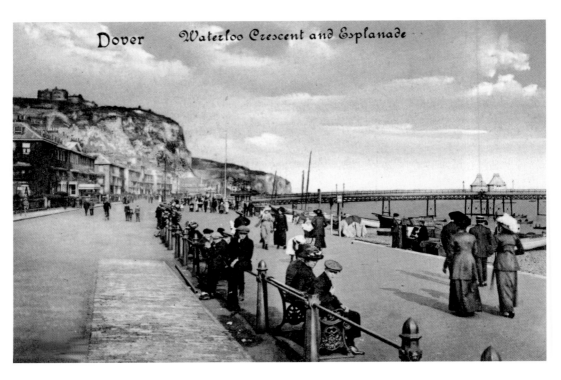

Dover Waterloo Crescent and Esplanade

Waterloo Crescent

Waterloo Crescent was built by Philip Hardwick in 1834-38. In 1949, this terrace was listed as Grade II building to ensure its future preservation.

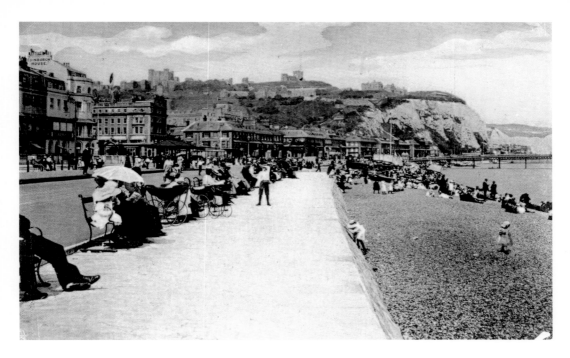

Sea Change

Sea Change is the name of a regeneration scheme under Dover District Council. The plans are based on some of the schemes initiated in Barcelona before the Olympics held there in 1992. The designs aim to link the castle and town to the docks and seafront. So far an impressive walkway and hard landscaping has enhanced the foreshore.

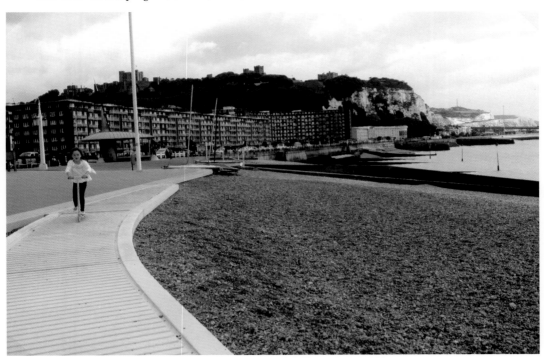

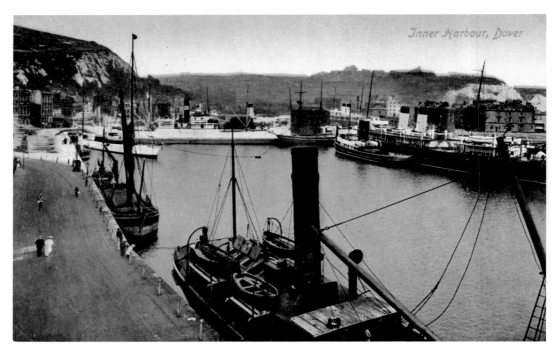

Inner Harbour, Dover

Inner Harbour I

Admiralty work on extending the harbour piers ended temporarily in 1875 due to high costs. Dover Harbour Board, however, then completed the Inner Harbour which now forms part of a busy yacht marina.

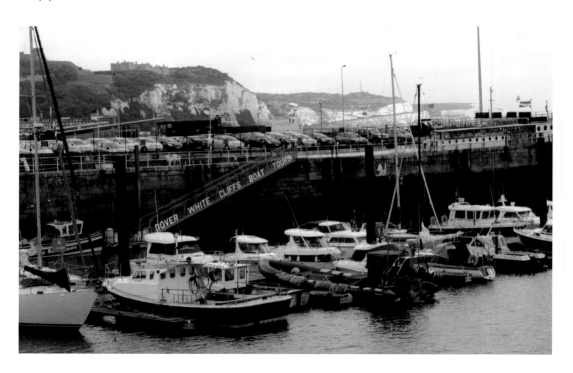

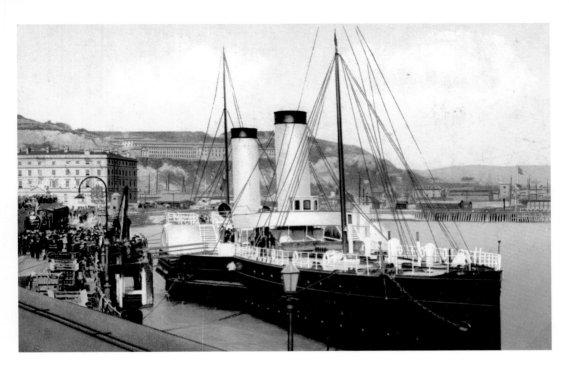

Cross Channel Paddle Steamer

The railways came to Dover in 1843. The first company to arrive was the South Eastern Railway Company. It was followed by the East Kent Railway Company in 1861. The two companies merged in 1899. Tracks extended to the docks, as seen in the picture above, where passengers could embark for France. A good idea of how hard work it was stoking the boilers of these old steamers can be seen from the grimy faces of their crew below.

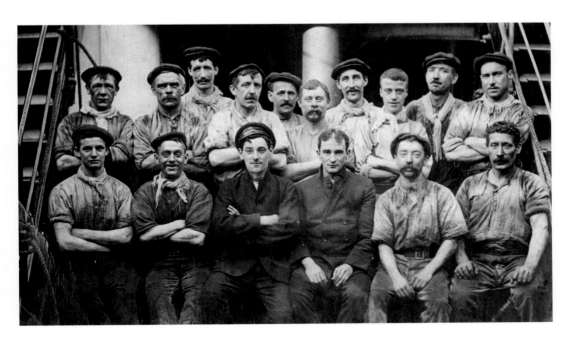

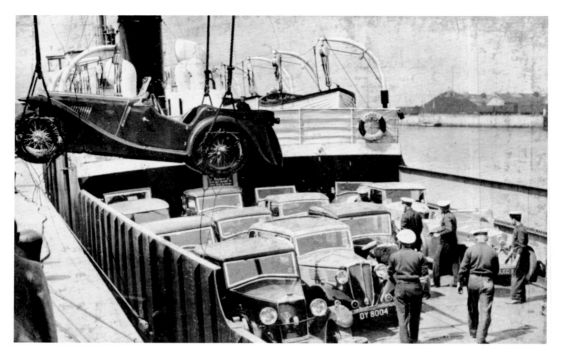

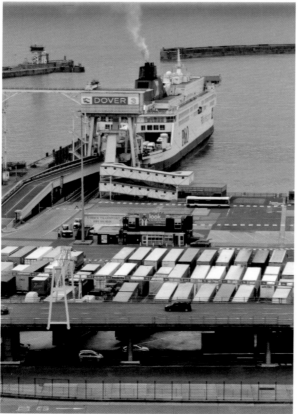

Car Ferries
In the late 1920s, companies began services for motorists to ferry their cars to the continent. Link spans superseded cranes at the Eastern Docks in 1955.

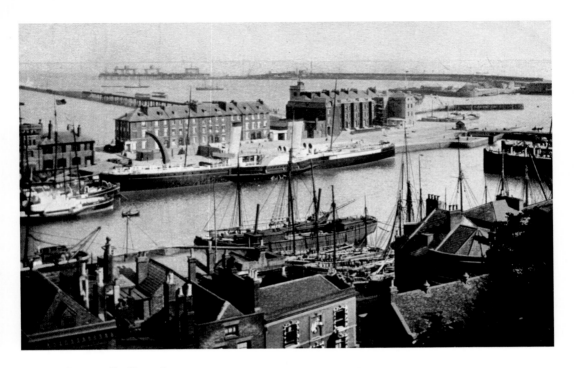

Roll-on, Roll-off Ferries
In the 1950s, the Eastern Dock was adapted to take roll-on, roll-off ferries. By 2008 traffic volumes had grown to 14 million passengers, almost 3 million cars and around 2.5 million trucks and coaches. This was despite competition from the Channel Tunnel and budget airlines.

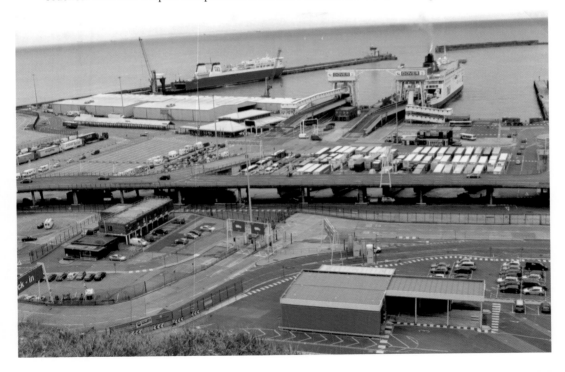

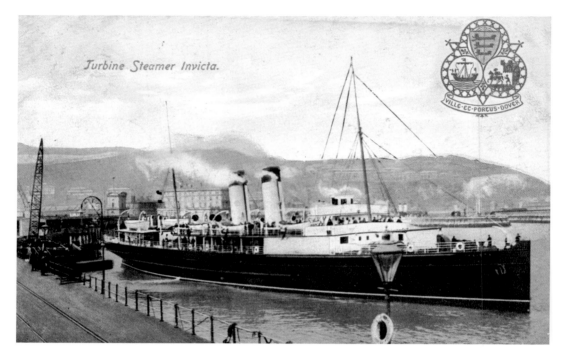

Turbine Steamer Invicta.

VILLE·EC·PORCUS·DOVER

Paddle Steamers Replaced by Turbine Steamers

Turbine steamers began to replace paddle from 1902. The Prince of Wales Pier was opened this year and for a brief period German transatlantic liners, such as the *Deutschland*, stopped here. Below is a familiar sight of a present day car ferry coming into dock from Calais.

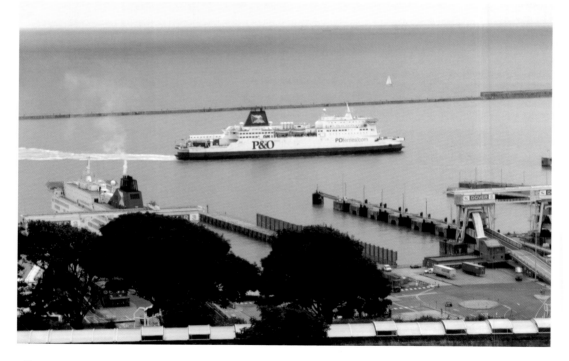

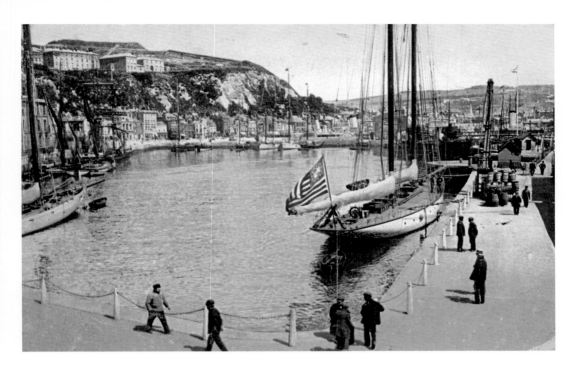

Inner Harbour II

After the Admiralty were put off by the cost of a harbour of shelter in 1875, Dover Harbour Board completed the Inner Harbour. The picture above shows this facility being used by an American vessel similar to the J class, which were the reserve of the wealthiest international yachtsmen.

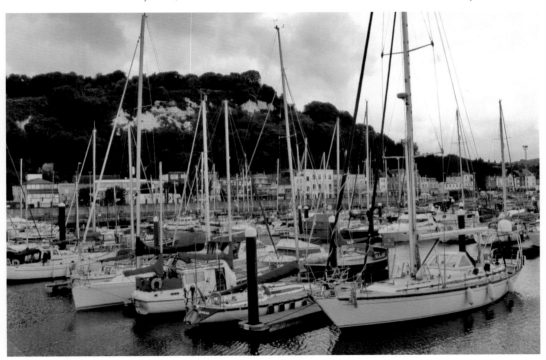

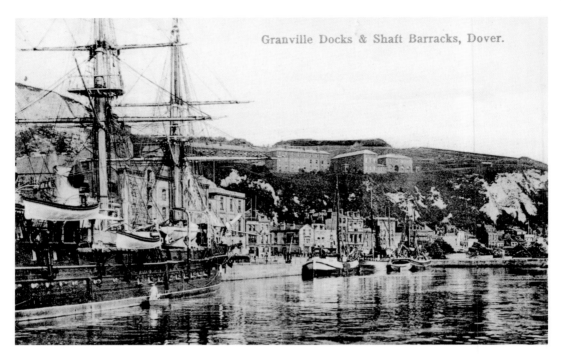

Sailing Craft, Old and New at Dover

The image above depicts a tranquil scene at Dover from the age of sail. Tied up at the quayside is a fine old square rigger. Now this basin is filled with the fibre glass hulls of expensive pleasure yachts.

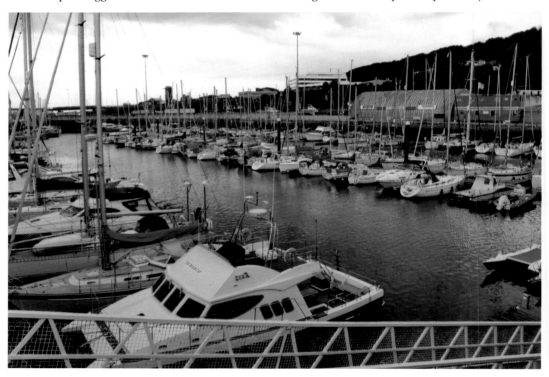

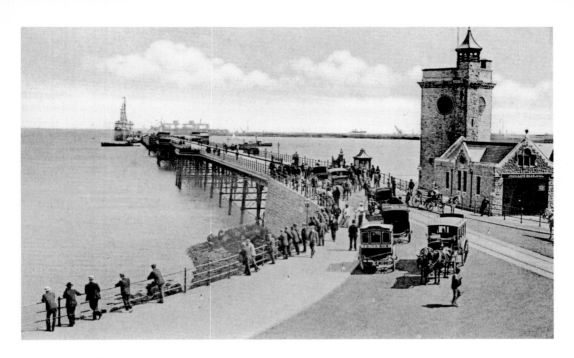

Prince of Wales Pier

Named after the Prince of Wales, who laid the foundation for this pier in 1892, it was used briefly as a docking place for large ships requiring deep waters. A railway track was laid to service these berths. The postcard above illustrates the first American liner using this facility. However, once the outer harbour was complete the currents between Admiralty Pier and Southern Breakwater made this usage too dangerous. A hoverport and catamaran port have since been constructed here.

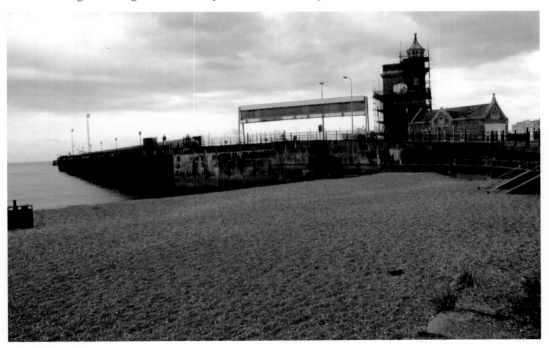

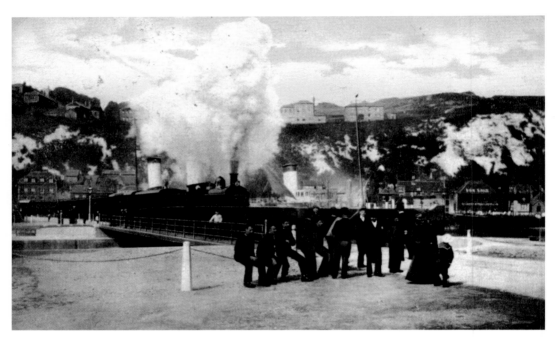

Wellington Bridge

Originally designed to carry trains to the quayside, this bridge has now become a roadway only. In the Edwardian scene above, army barracks can be seen prominently overlooking the docks. It was these that the Grand Shaft serviced.

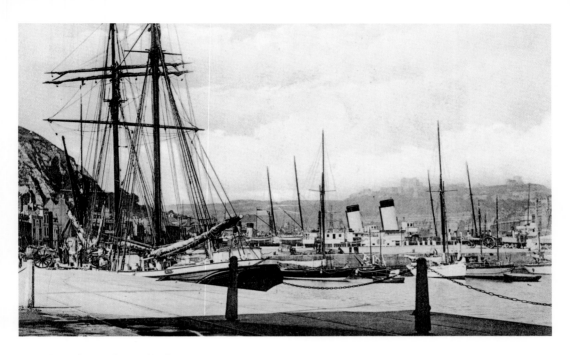

Ferryboats Dover Harbour
These pictures of ferryboats tied up at Dover quayside are from the 1930s and 1950s. In the above scene square riggers mingle with steam ships. Whereas below all the commercial boats were mechanically driven.

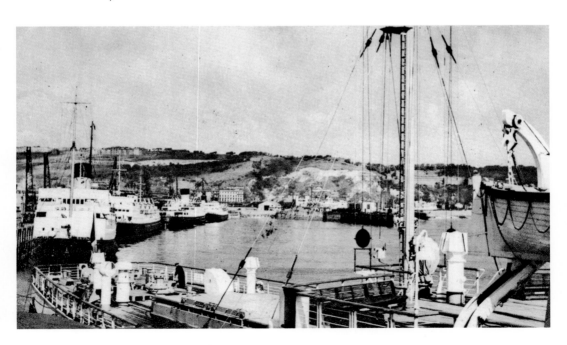

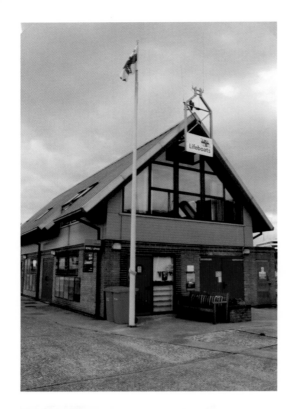

Dover Lifeboat
Dover has had a lifeboat since 1837. The station was taken over by the RNLI in 1855. The present boat is a 17 metre Severn class all-weather craft, funded by City of London Branch Centenary appeal plus legacies from E. Horsfield, G. Moss and others.

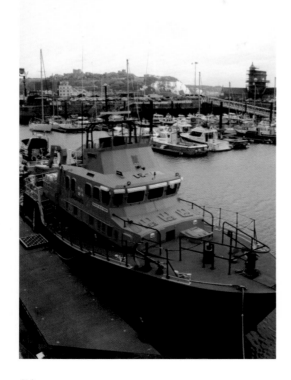

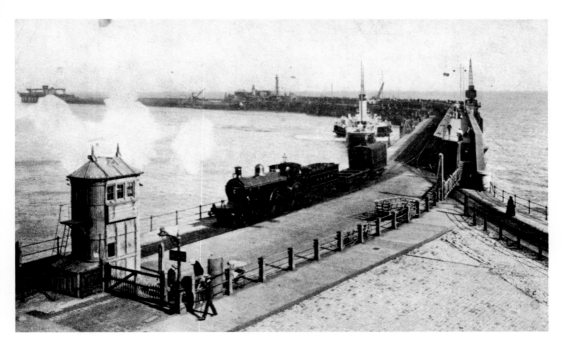

Admiralty Pier

To build a refuge harbour for the Royal Navy, a foundation stone was laid in 1848. It took six years to construct a pier of 800ft. Then an extension of 1000ft was begun to provide a dockside for cross channel steamers. By the 1860s the two railway companies servicing Dover brought their rolling stock alongside their ships. Another section of 300ft was added in 1875 culminating with a defensive turret. At the turn of the century an ambitious fourth phase made a harbour with another 2000ft bringing the total length to 4140ft.

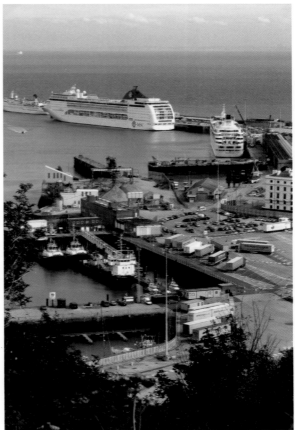

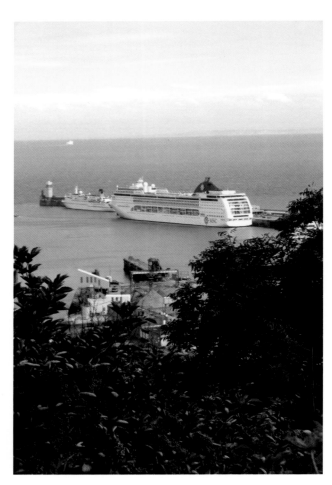

Liner Port Dover
A large passenger liner departure terminal operates from the old Admiralty Pier. Viewed from Western Heights the port looks as though it could be a Caribbean anchorage. However, a closer look at the horizon shows the distant shoreline of France.

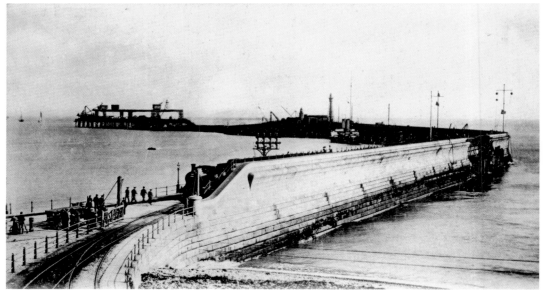

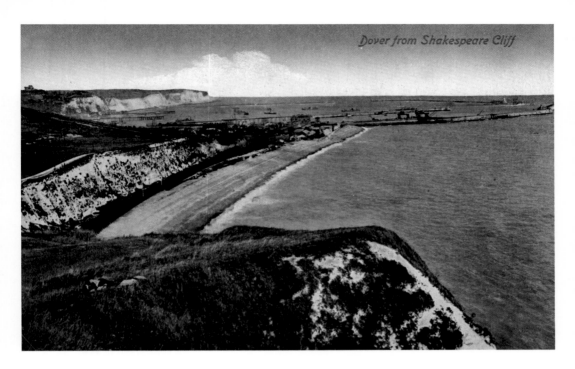

Dover from Shakespeare Cliff

Western Heights

High above Dover on the Western Heights the Citadel was constructed, and many other defensive installations. Until recently a borstal institution operated here, but a detention centre for foreign asylum seekers has taken its place.

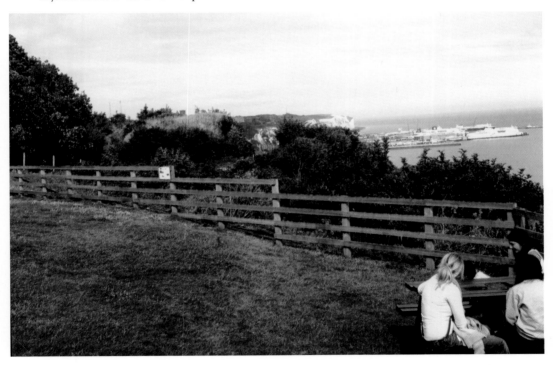

Archcliffe Fort

Archcliffe Fort stands on a headland overlooking the western end of Dover Harbour. It was established in 1370 as a watchtower and continuously modified throughout history. However, by the Second World War it had become obsolete and with later rail and road developments partly demolished. The remaining buildings have now been adapted for use by the Emmanus Community. This organisation provides accommodation and workshops for recycling and retailing second-hand furniture.

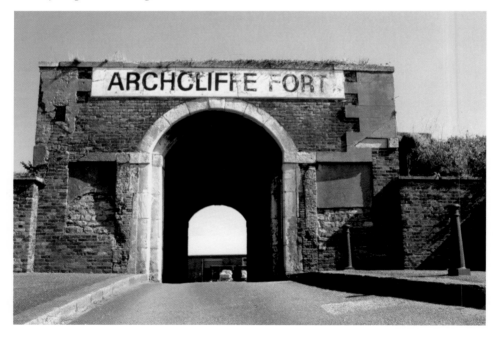

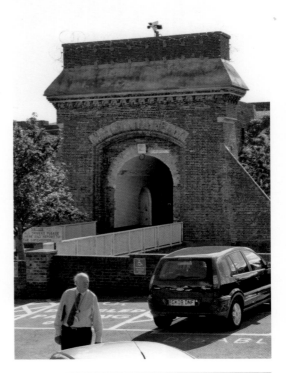

The Drop Redoubt and Citadel

These two forts on Western Heights were interlinked and designed to hold a large force able to attack any invading army from the rear. Most of what remains are mid-Victorian structures. The Citadel became a Borstal and is now a detention centre for illegal immigrants. It is surrounded by security fencing and is out of bounds to the public, but English Heritage allows access to parts of the Drop Redoubt.

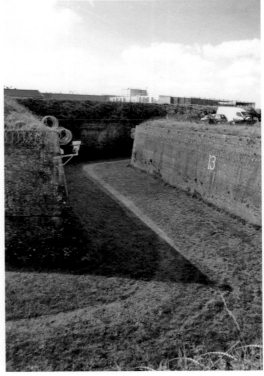

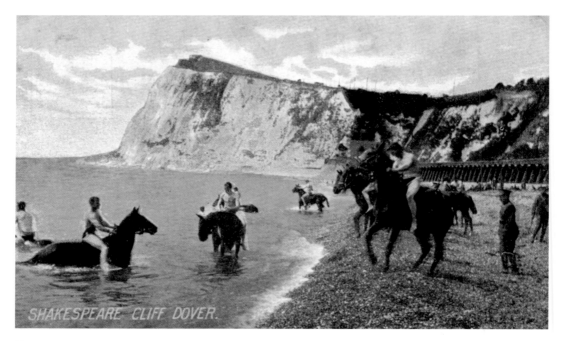

SHAKESPEARE CLIFF DOVER.

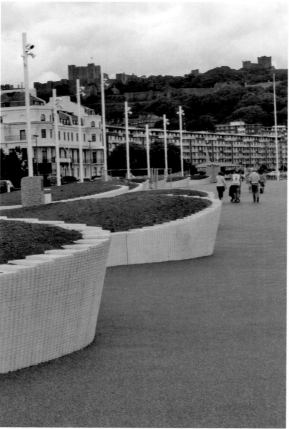

Shakespeare Cliff

The tall white cliff of chalk near Dover derives its name from a reference in Shakespeare's play *King Lear*. The blind character Gloucester (who is almost as mixed up as King Lear himself) asks his son Edgar to lead him to suicide over this prominence. Unchanging in appearance from eighteenth-century prints of this spot, the postcard above shows cavalrymen exercising their horses here. More recently, Dover District Council, in cognisance of the strong imagery aroused by this famous landmark, has attractively replicated this theme with its new hard landscaping at the seafront.

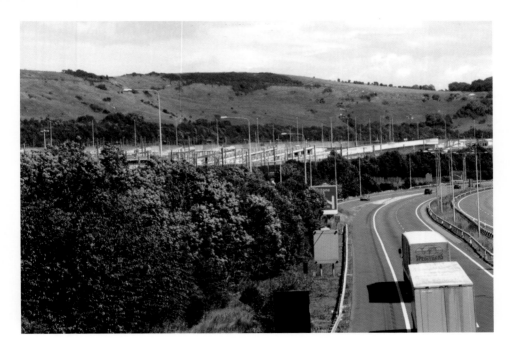

The Channel Tunnel

The gestation period for this impressive feat of civil engineering was a long one. Over two hundred years ago mainly French entrepreneurs pursued the idea. However, due to concern over weakening national security it was not until 1881 that the British Government consented to an exploratory bore hole at Shakespeare Cliff. This was soon abandoned for the usual political anxieties, but finally in 1994 a tunnel was completed after six years of construction and much financial overstretch.

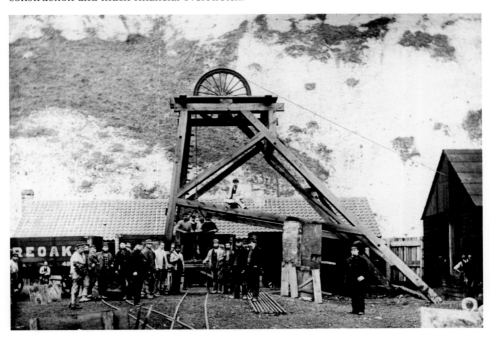

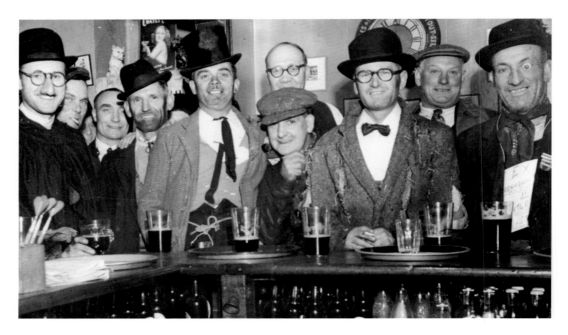

The Old Endeavour Public House

This Dover pub was named after a privateer ship which was fitted out at Dover in July 1746. It is currently for sale, but in the past it has been a hub of community life. The Ton-up Vicar, Revd William Shergold, founded the 69 Motorcycle Club here. A glorious glimpse of previous fun here can be appreciated from the photograph above of revellers at a tramps night.

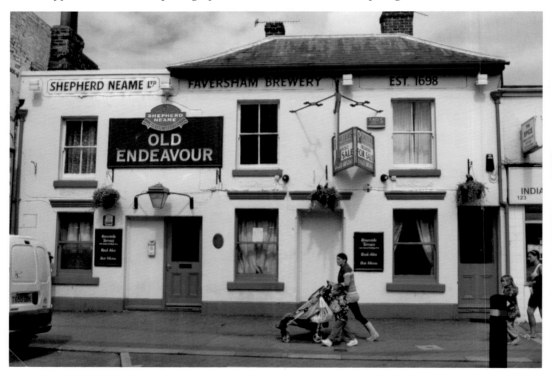

Dover's Member of Parliament for Twenty-Four Years

Wyndam held the seat of Dover for a generation until his death in 1913. He was a well connected politician who as Chief Secretary for Ireland introduced the 1903 Land Act. This radical reform brought about a transformation of land ownership in Ireland, from landlords to previous tenants. A man of letters and one of 'souls', he was noted for his elegance. It is easy to understand the speculation over the years that Wyndham was the natural father of Anthony Eden who was Prime Minister from 1955-57. His mother was close to Wyndham to whom Eden bore a striking resemblance. The portrait photograph right shows a similar suavity and attractively engaging directness of gaze. Below is the formal announcement of Wyndham's election to Parliament, in 1906.

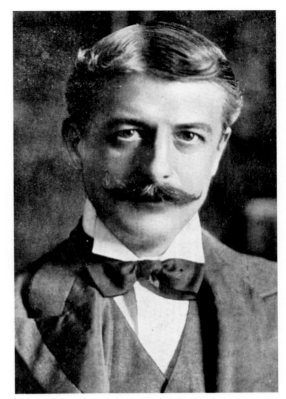

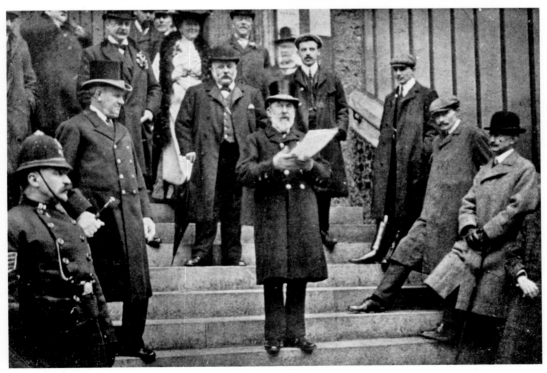

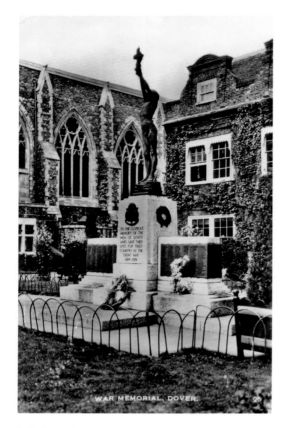

WAR MEMORIAL, DOVER.

War Memorial
This statue and its setting were designed by Reginald Goulden who was a son of Dover, and became famous for his memorial works. Initially built to mark the loss of casualties in the First World War, the names of those lost in the Second World War were later added.

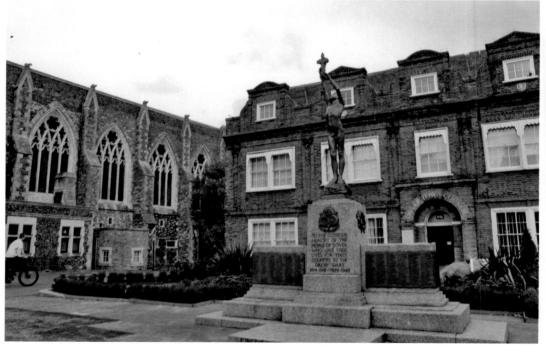

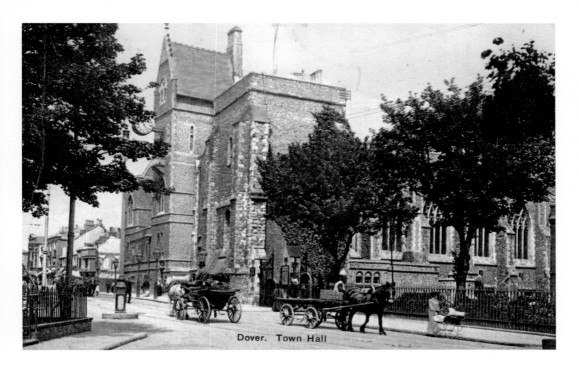

Dover. Town Hall

Maison Dieu

Houses of God or hospices were developed for shelter by monastic communities along pilgrim's routes to the shrine of Thomas Becket in Canterbury during the early medieval period. However, following the upheavals of the Reformation, the Navy used these buildings as a store. By the 1830s they had been acquired by Dover Corporation. A jail was added and in 1881 Connaught Hall. While structurally still easily recognisable the street scene has evolved from horse-drawn vehicles and tram lines to motor cars and yellow parking lines.

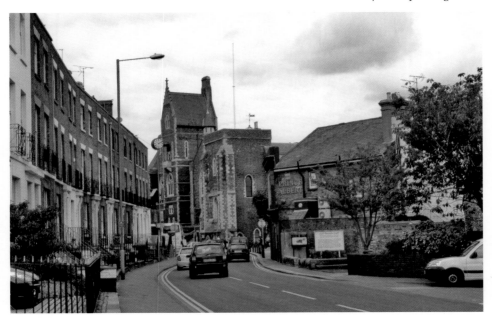

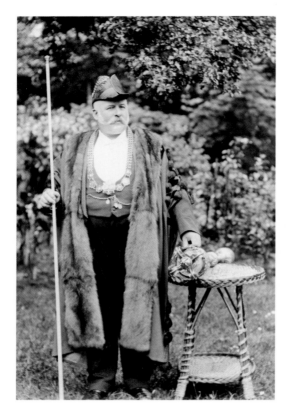

A Municipal Place and Personage

Maison Dieu House was built in 1665 to house the Agent Victualler of the Navy, who supplied the Channel Fleet. Its dormer windows are false and were merely for decoration. After some time as a domestic house, Dover Corporation bought the premises in 1899. In 1905, W. Burkett JP was mayor. He is posing for posterity left as the epitome of aldermanic pride, resplendent in cocked hat and magnificent handlebar moustache.

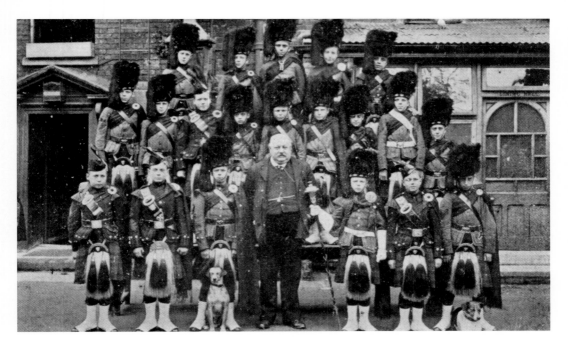

Two Institutions for Dover Children that have Closed

The Gordon Boys Orphanage in St James's Street was founded by Thomas Blackman in memory of General Gordon, who was killed at Sudan. A core activity of the school was its band. Pupils were instructed by retired army bandsmen and a high standard of music was played at parades around Kent. The picture below is of Ursuline Convent School in Park Avenue, which like many other small convent schools for girls, has now closed.

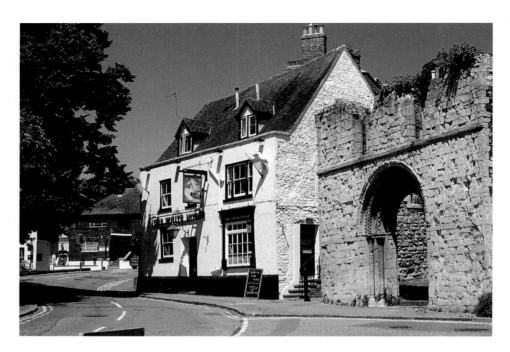

Old St James Church

Known as Dover's tidy ruin, old St James Church was built in the Norman style, *c.* 1070. Its roof was damaged from fragments of a bomb dropped by a German seaplane on 19 March 1916. Restored in 1931, its vulnerable position meant that it was hit irrevocably in the Second World War. The crumbling tower fell in 1950.

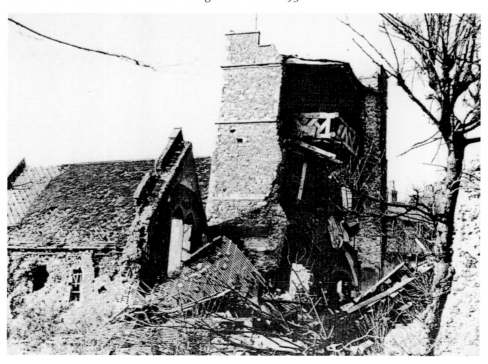

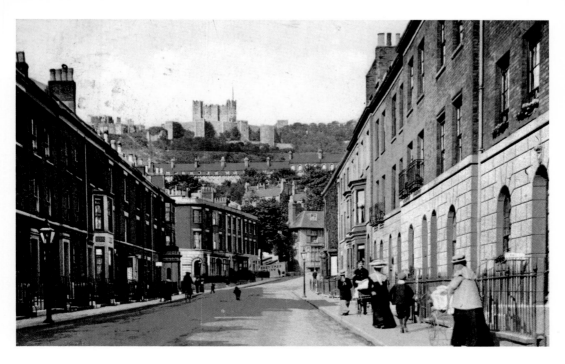

Castle Street

Once part of the town's tram routes, this late Victorian street is lined with offices of professional firms and other businesses. The brooding presence of the castle above provides an excellent focus for the good perspective of this road.

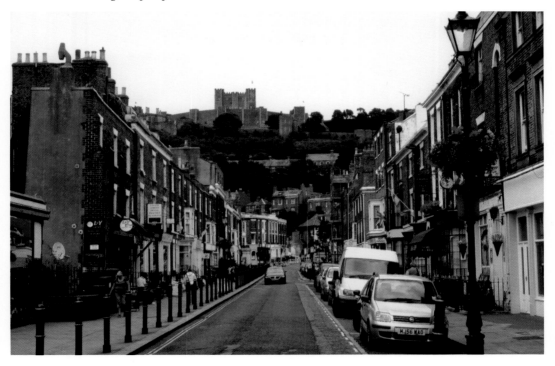

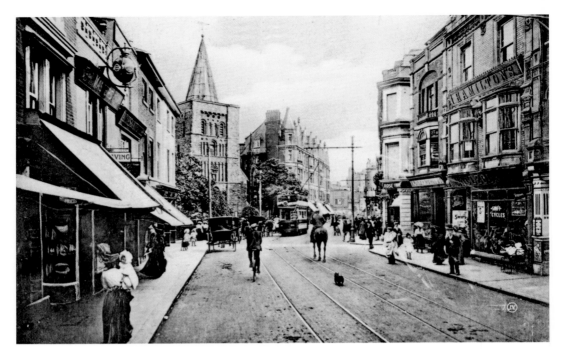

Biggin Street I

Biggin Street is one of Dover's main shopping streets. It takes its name from Biggin Gate, which was an opening in the old town wall on the road to Canterbury and London beyond. The gate was demolished in 1762, but two historic buildings remain – the Maison Dieu and Maison Dieu house. This Edwardian snapshot above shows an uncongested street, but a survey in 1893 showed that the narrow thoroughfare was severely blocked with heavy traffic at rush hours and therefore a widening scheme was adopted.

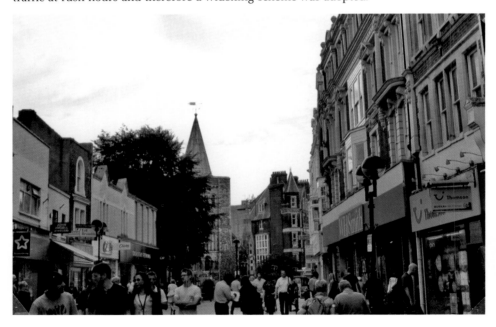

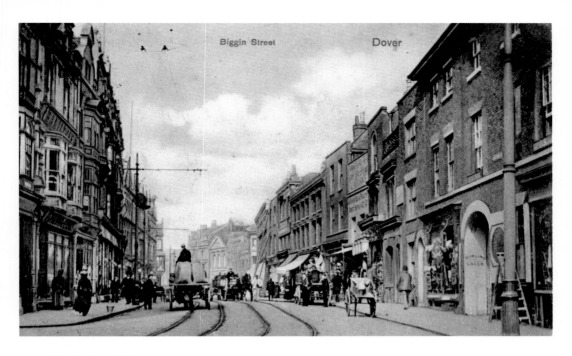

Biggin Street II

Still one of Dover's main shopping precincts, Biggin Street no longer reverberates to the sound of clanging trams. Pedestrians now wander where horse-drawn vehicles used to travel. As seen by comparing these old and new pictures, the buildings on the right hand side are much altered from a century ago.

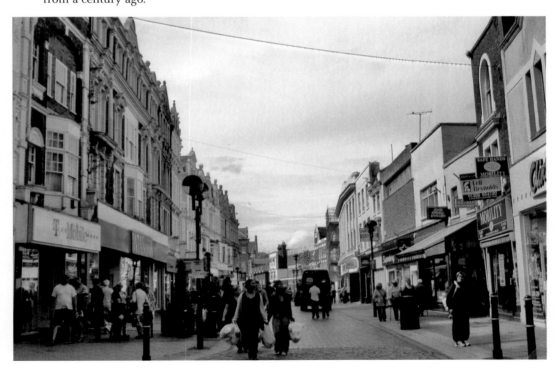

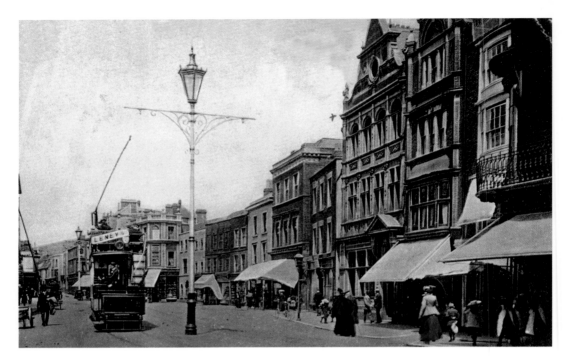

A Tram in King Street
The tram car seen here in King Street is carrying an advertisement for Leneys, a renowned local store of the time. In the contemporary photograph below, boulevardiers are relaxing with coffee at an English café whereas round the corner a Polish café is thriving on trade from immigrant workers.

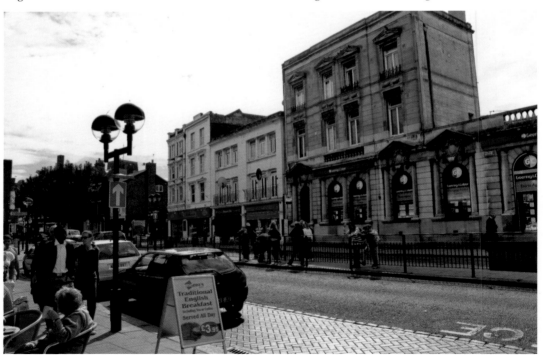

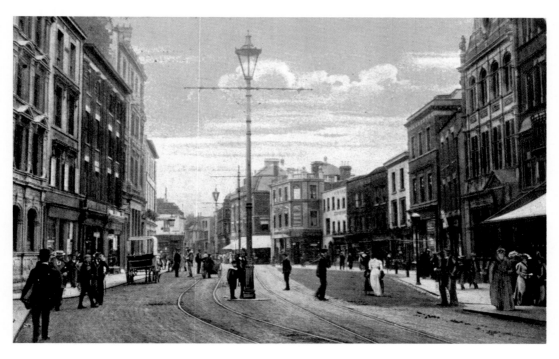

King Street

Damaged by enemy action during the Second World War, King Street is considerably altered from the postcard picture above. A small detail to note is that the pediment on the tall right hand side building no longer exists.

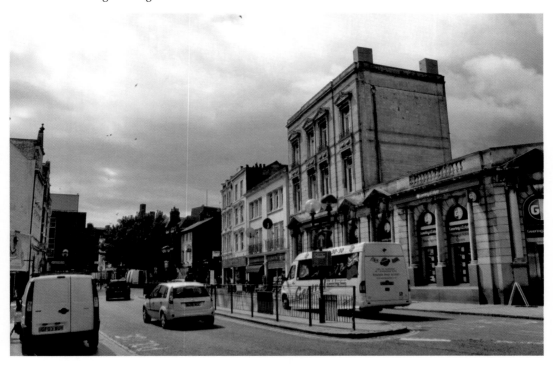

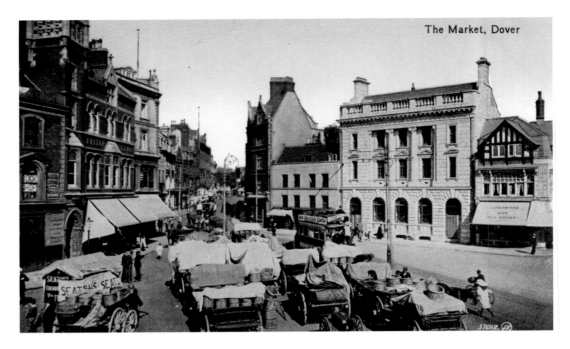

The Market, Dover

The Market Square

Much altered and reinvented over centuries, this part of Dover was originally where Romans harboured their vessels. The postcard view above shows farmers' carts laden with produce to sell. The Victorians demolished an old guildhall here, similar in design to the one in Faversham (with high chambers above stilts). Also an early town gaol was located here. Of particular literary note are the shop steps upon which poor David Copperfield rested on his search for the home of his Aunt Betsy Trotwood.

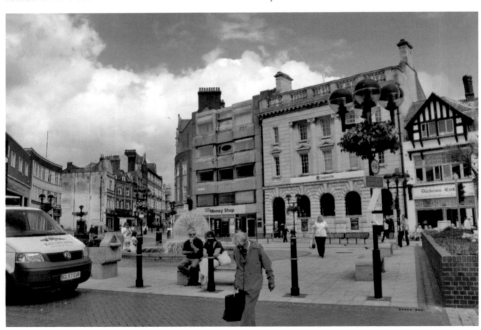

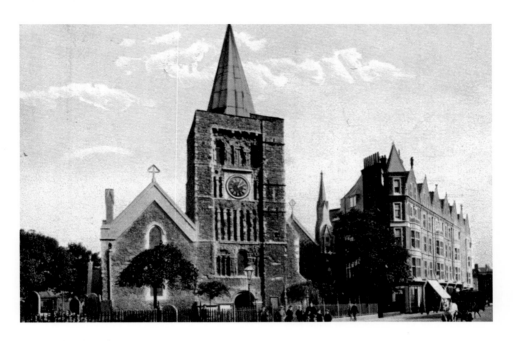

St Mary's Church

Standing proudly in Cannon Street near the centre of town is the civic church of Dover. It has been a place of worship from the very earliest years of England's Christianity. Many important services have been held here including a memorial to those who died in the *Herald of Free Enterprise* cross channel ferry tragedy of 1987. Currently its thriving Anglican congregation has an active children's section, musical distinction – both from its choir and staged concerts, together with tangible care and outreach for foreign visitors down on their luck.

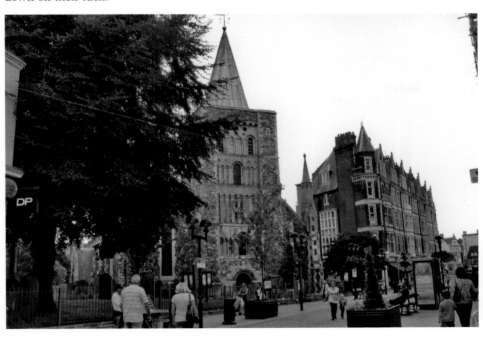

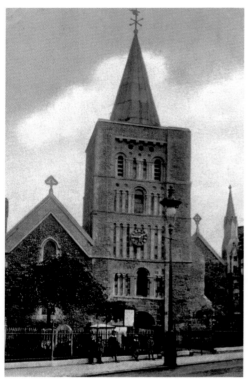

St Mary's Church Tower
In 1843-44, the old medieval church was rebuilt with the exception of this fine Norman style tower.

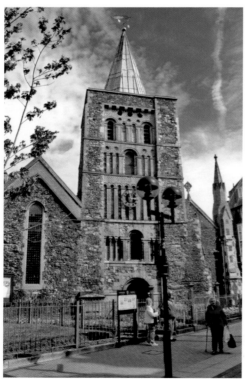

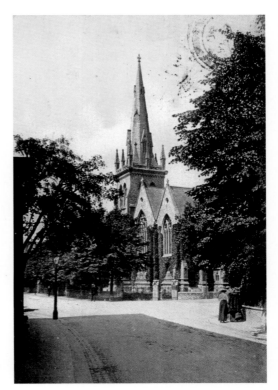

New St James Church
Like its older neighbour nearby, New St
James Church was a victim of German
shellfire. Its gates and altar, however, survive
today as parts of a school playground.

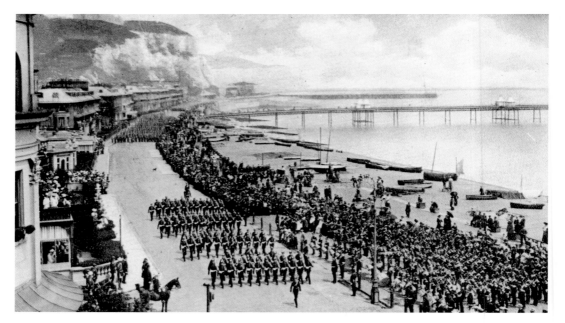

King's Birthday Parade
With a garrison of, at times, up
to eight thousand soldiers at
Dover, the King's birthday was
an excellent occasion to show
off their ceremonial prowess.
This part of the sea front has
recently benefited from many well
designed enhancements including
a sea sports pavilion and covered
seating.

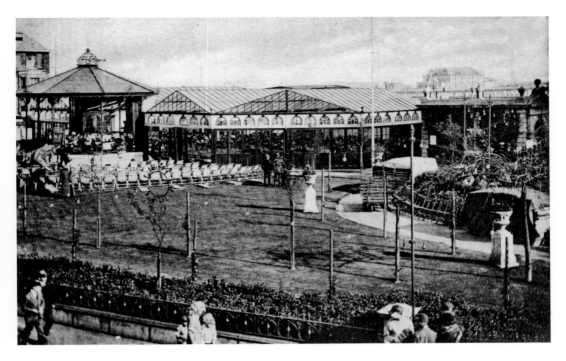

Band pavilion
Much of the buildings around this garden were victims of Second Wold War bombing. The band stand and pavilion have been lost, but eventually the smaller scale gardens photographed below were reinstated.

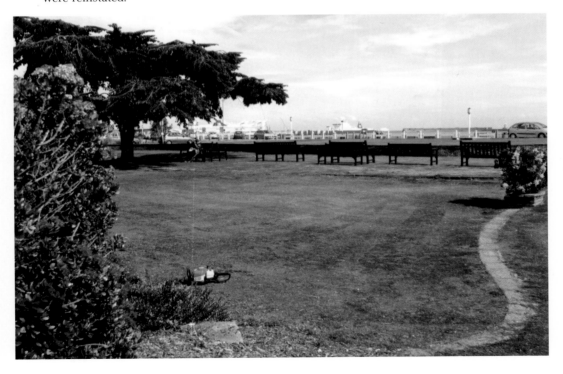

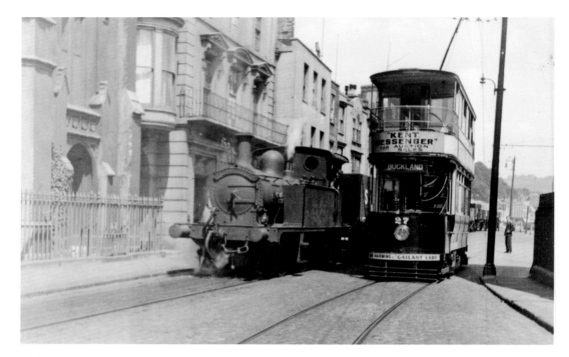

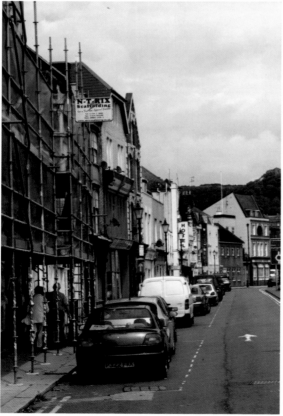

Dover Trams

Dover Corporation's tram service was only the second one to be installed in the UK. It was an immediate success having cost £28,000; it made a profit of £1,300 in its first year of operation. A staggering 1,794,905 passengers travelled on it in 1898. It is easy to imagine that Snargate Street was a precarious place for pedestrians when both steam locomotives and trams rattled along its course in tandem.

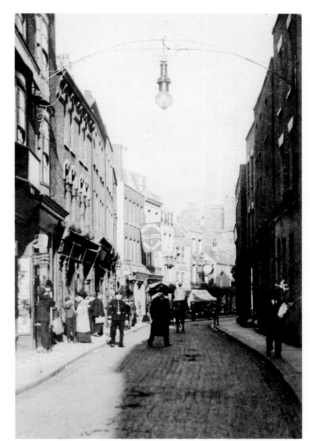

Old Snargate Street
Snargate Street has altered
considerably from the photographs
here. To accommodate road widening,
the buildings on the right hand side
have been demolished. In its heyday,
however, this was an important
trading area near to the docks and
army barracks.

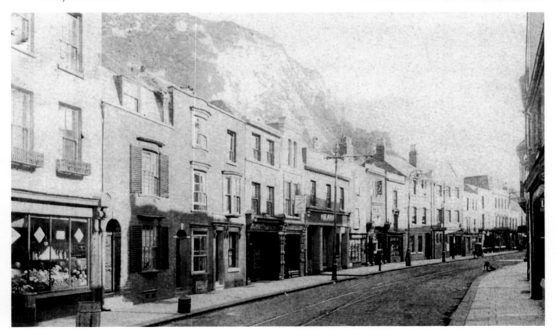

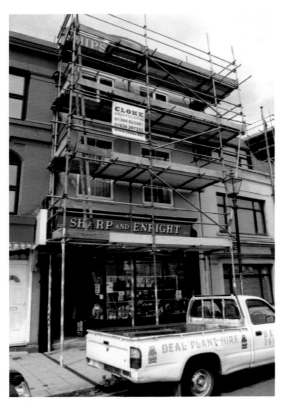

Snargate Street Chandlers

Sharpe and Enright have been established as chandlers in Snargate Street for well over 150 years. The present proprietor, Mike Sharpe, pictured below, is the fourth generation of his family to be in business here.

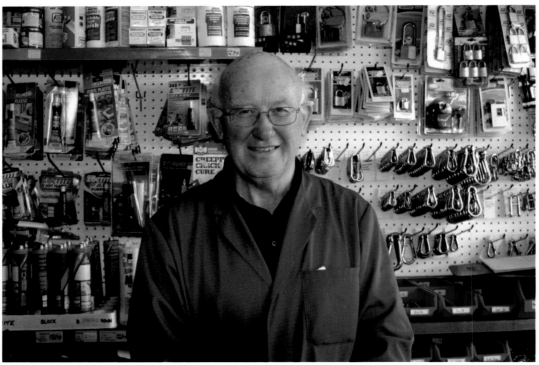

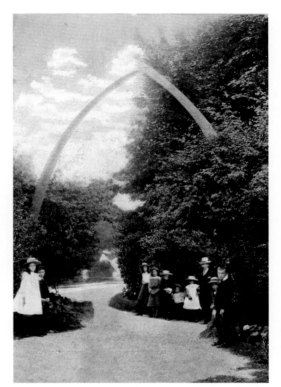

Connaught Park, Dover
This was established as Dover's first park in Victorian times. Sadly the whale bone arch, shown in the Edwardian postcard, has been removed due to vandalism.

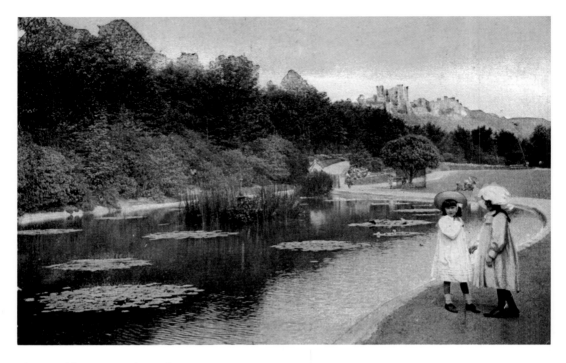

The Pond in Connaught Park

Opened by the Duke of Connaught when he was visiting the town; the grounds of Connaught Park are little changed except that the trees have matured. An unusual feature of this recreation ground is the aviary near the entrance.

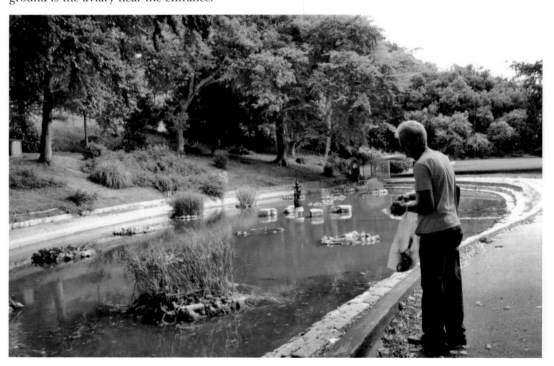

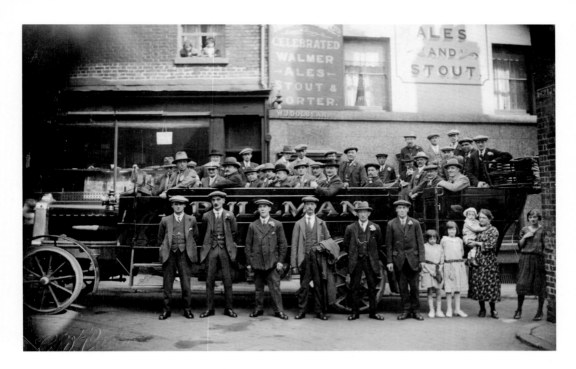

Dover Open Buses

The scene above is redolent of the interwar years. A very smart party of men are about to leave on a Sunday outing. The charabanc they are travelling in has solid rubber tyres and is parked outside the licensed premises of W. J. Dolbear (possibly the Prince Regent, Market Square 1823-1983). Below is a much later converted double-decker used to convey mainly holiday makers around coastal roads.

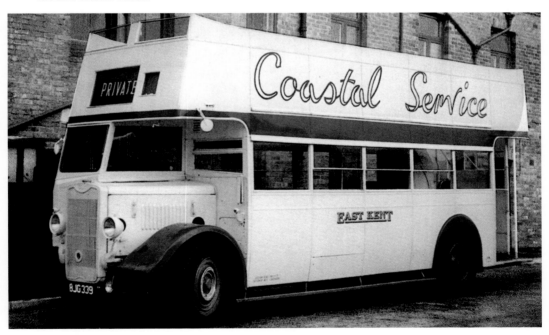

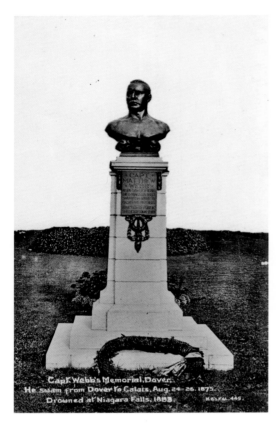

Channel Swimmers

The first man to complete the feat of swimming all 21 miles of the Channel was Captain Webb, in 1875, who is commemorated by this statue facing Dover Harbour. The bust was moved from its original place in front of the Burlington Hotel. Many others attempted and some succeeded in the brave Captain's 'slipstream', but one who failed valiantly six times was E. Heaton. His backup team headed by Captain William George Sharpe of the Dover tug *Lady Curzon* (whose husband at the time was Lord Warden of The Cinque Ports) are seen below posing for posterity.

Inset: A modern day channel swimmer.

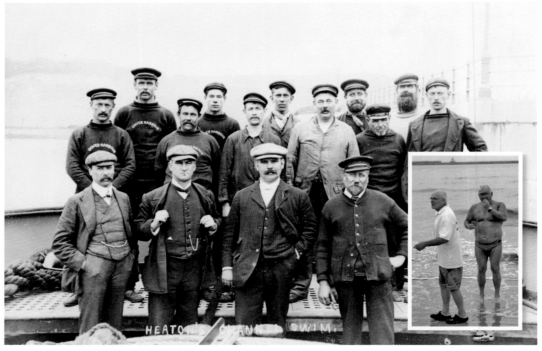

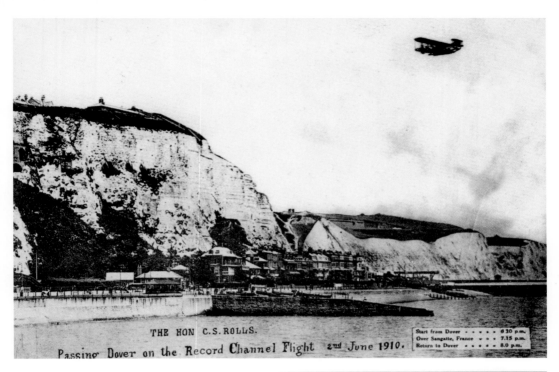

THE HON C.S. ROLLS.

Passing Dover on the Record Channel Flight 2nd June 1910.

Start from Dover	6.30 p.m.
Over Sangatte, France	7.15 p.m.
Return to Dover	8.0 p.m.

Charles S. Rolls, Pioneer Aviator
The Hon. Charles Rolls was the first man to cross the channel and return in a single flight on 2 June 1910. Sadly he was to die in a flying accident only weeks after this event. A century later his achievements and his famous company Rolls-Royce were celebrated with a magnificent exhibition in central Dover.

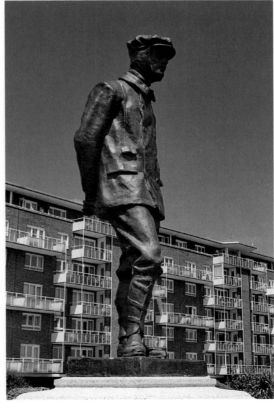

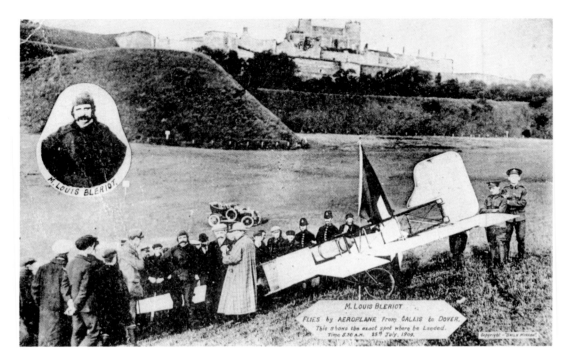

Louis Bleriot

Winning the Daily Mail prize of £1,000 for completing the first flight of the Channel, this French engineer went on to become a major aircraft manufacturer. His early fortune was made by the invention and then production of car headlights. Commercial success from this activity funded an interest in flying. To commemorate the centenary of Bleriot's pioneering feat of aviation, in 2009 his memorial landing spot was renovated and a similar flight re-enacted.

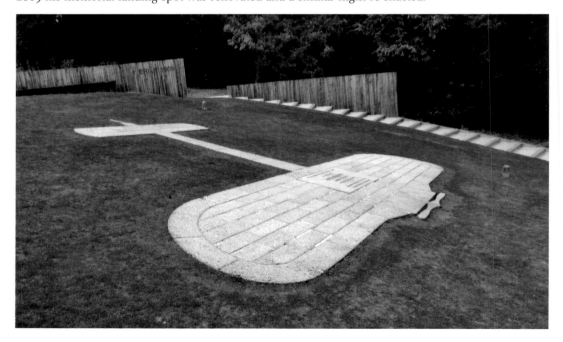

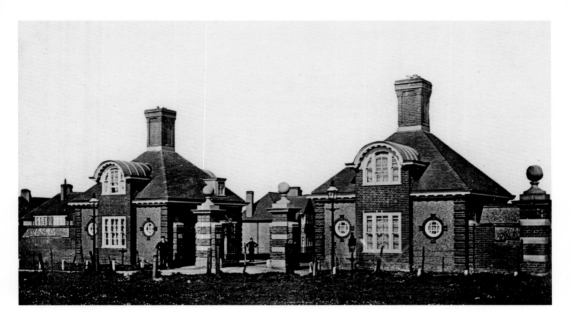

Sons of the Brave

The above is the motto of the Duke of York's Military School. It was established in Chelsea in 1803 to educate orphans of British servicemen killed in the Napoleonic Wars. Relocating to a new site above the cliffs of Dover in 1909, it now has exceptional sporting facilities within its 150 acres of grounds. In September 2010 the school will become an Academy, open also to children from a non-military background and it will be supervised by the Department for Education rather than The Ministry of Defence.

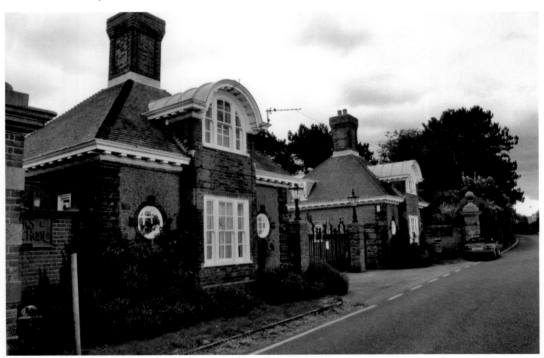

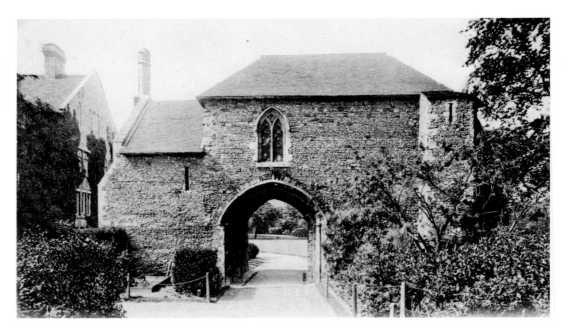

Dover Priory

Only a few buildings of Dover Priory remain. It was once, however, a large ecclesiastical community. King Stephen was said to have died here while resting from a journey. In the eighteenth century the ruins were used as agricultural buildings, but by 1869 their future preservation was guaranteed when they became the nucleus for Dover College.

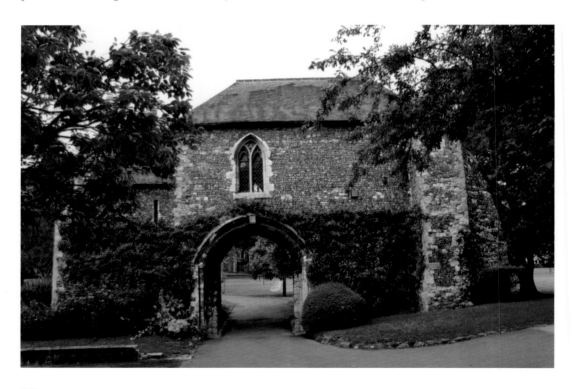

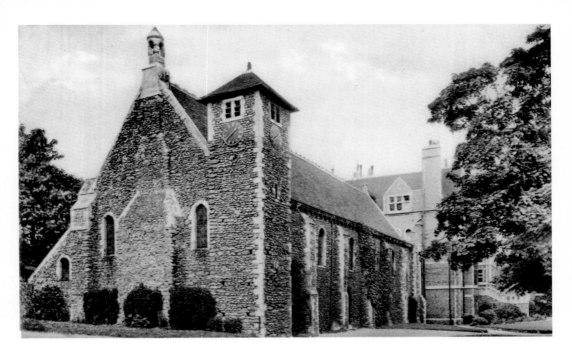

Dover College

Dover College is a co-educational school founded in 1869. Its precincts include buildings surviving from St Martin's Priory. The refectory retains its original use, while the monk's dormitory is now a chapel and the gatehouse a music centre. Notable old Dovorians include many distinguished military men. Arthur Harrison received a posthumous VC for his valour during the Zeebrugge raid 1918. In the next major war, Col. Terrence Ottaway was awarded a DSO for his part in the attack on D-Day of Merville Battery. The late Sir Frederick Ashton of the Royal Ballet was also an old boy, as is the more recent alumni Simon Cowell of TV personality fame. Jeffrey Archer, the pulp fiction writer, taught at this school briefly in the 1960s.

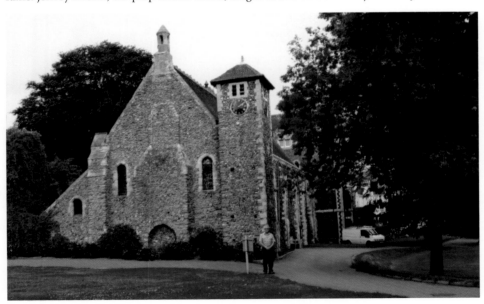

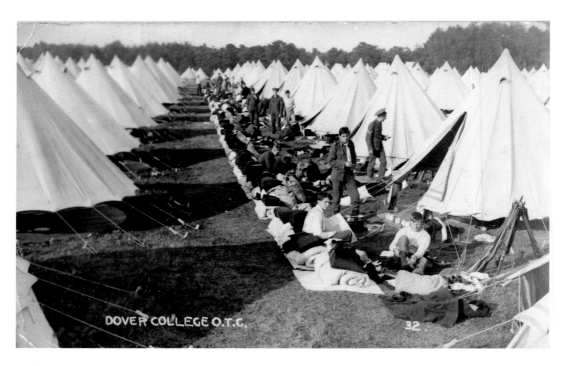

Soldiering On

Officer Cadet training corps was once part of every boy's boarding school curriculum. Dover College was no exception and an impressive display of order and discipline is pictured in this old photograph of one of their summer camps. Below this scene is a snapshot of the London Scottish Regiment garrisoned at Dover with a field kitchen in full swing.

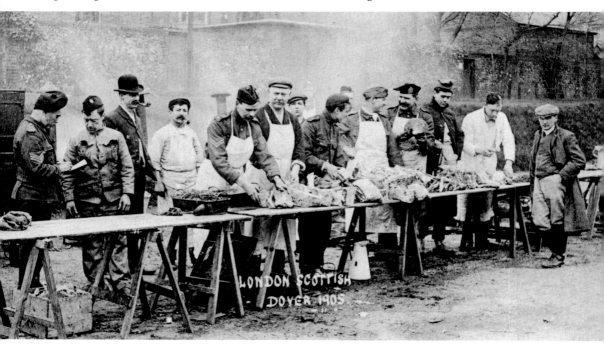

The Grand Shaft, Western Heights
The Grand Shaft, Western Heights, was built in 1806-9 to provide quick access to the harbour for troops stationed in the barracks above. Its unique design incorporated three stairways, which in later years were separately designated by military rank. The Victorian photograph below shows workmen mining later tunnels and fortifications. It was expertly taken by one of Dover's professional photographers, namely Charles Harris of 77 London Road.

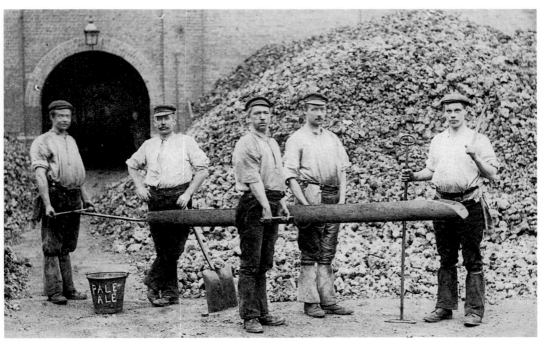

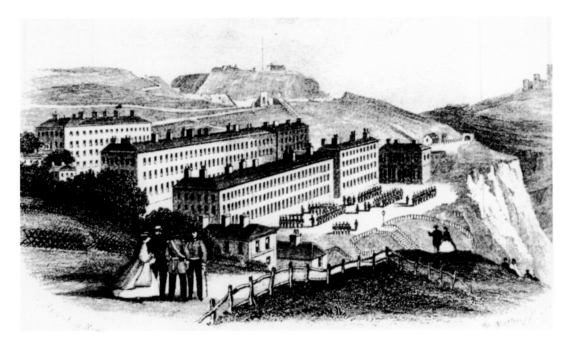

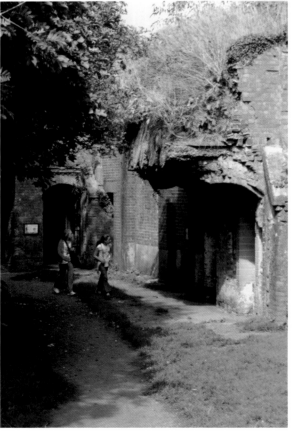

Grand Shaft Barracks
During the Napoleonic wars
vast military installations were
constructed on or around the cliffs
of Dover. The barracks shown in
the print above illustrates those that
were served by the Grand Shaft. Left
are the remains of tunnels in the
Western Heights.

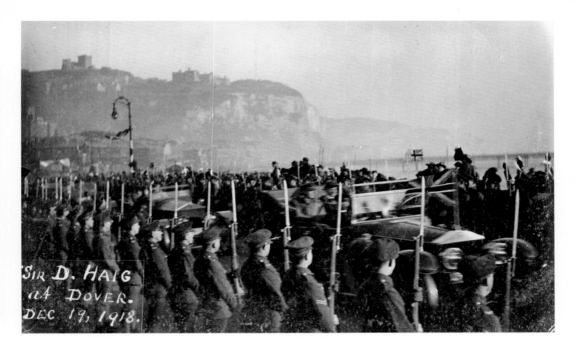

Sir D. Haig
at Dover.
Dec 19, 1918.

Wartime Views at Dover Harbour

Above is a rare postcard depicting General Sir Douglas Haig at Dover following the tumultuous First World War. His career has been much analysed, but like all good 'managers' nobody can deny that he did achieve the objective. Submarine warfare was, for the first time, a significant factor at this time. It was the reason for the Zebrugge raid and defensive sinking of the SS *Spanish* and *Livonian*. These wrecks are only now, in 2010, being broken up at the Harbour entrance to allow for passage of larger vessels.

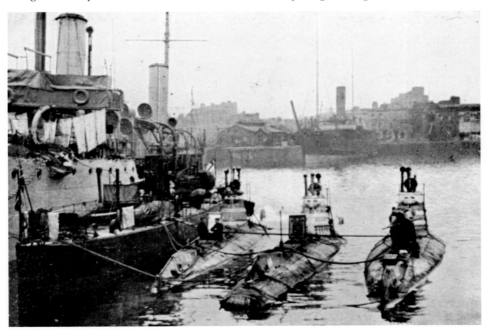

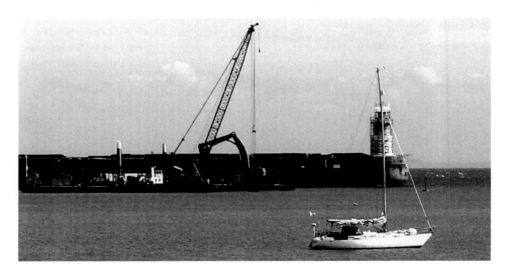

The *Spanish Prince* and its Association with Cmdr. Lightoller

The snapshot above shows the *Waasland* Sea Barge breaking up the wreck of *Spanish Prince* at the entrance to Dover Harbour. This wreck and another sunken vessel (highlighted in red on the chart below) were designed to protect the inner harbour from attack by U-boats in the First World War. The *Spanish Prince* was previously named the *Knight Bachelor* in 1897 when it was damaged by an iceberg in the North Atlantic. On board was a junior officer called Charles Lightoller. During repairs at Halifax, Canada he left the ship to join the Klondike gold rush. A decade or so later he was famous for being the most senior officer to survive the *Titanic* disaster. During the First World War he joined the Royal Navy and eventually served on the Dover Patrol. His adventurous career was further distinguished with heroic involvement in the Dunkirk evacuation of 1940.

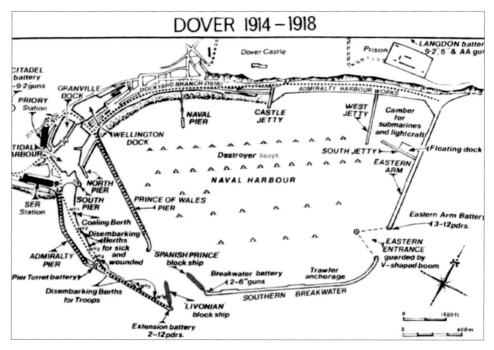

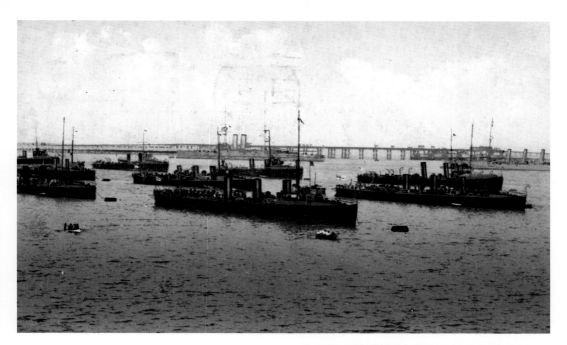

The Navy at Dover in the First World War

Designed to shelter a large fleet of warships, the harbour is shown at its zenith in the First World War. With the development of air combat its usefulness declined. The Zebrugge raid set off from Dover with many civilian volunteer craft. It was temporarily successful in blocking the entrance for shipping to Zebrugge. However, casualty losses were high and historians have played down the exuberant media reaction of the time.

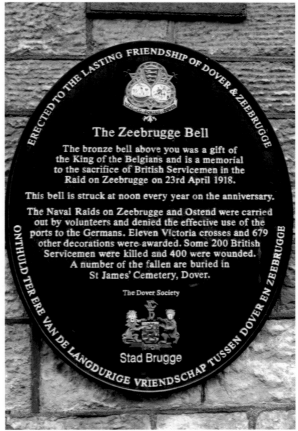

ERECTED TO THE LASTING FRIENDSHIP OF DOVER & ZEEBRUGGE

The Zeebrugge Bell

The bronze bell above you was a gift of the King of the Belgians and is a memorial to the sacrifice of British Servicemen in the Raid on Zeebrugge on 23rd April 1918.

This bell is struck at noon every year on the anniversary.

The Naval Raids on Zeebrugge and Ostend were carried out by volunteers and denied the effective use of the ports to the Germans. Eleven Victoria crosses and 679 other decorations were awarded. Some 200 British Servicemen were killed and 400 were wounded. A number of the fallen are buried in St James' Cemetery, Dover.

The Dover Society

Stad Brugge

ONTHULD TER ERE VAN DE LANGDURIGE VRIENDSCHAP TUSSEN DOVER EN ZEEBRUGGE

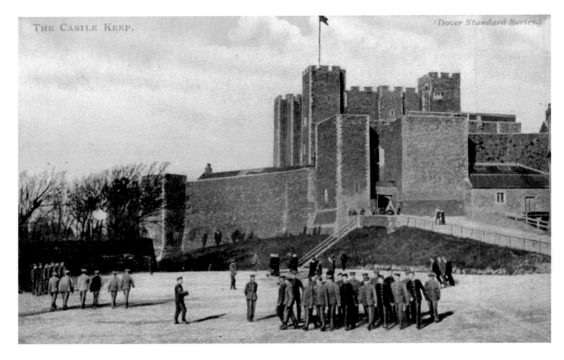

(Dover Standard Series.)

The First Bomb on English Soil

On a clear Christmas Eve in 1914, a German plane dropped the first bomb on English soil. The pilot manhandled the bomb overboard narrowly missing his target of Dover Castle. As a strategically vital town with a huge garrison and important naval installations, Dover was to receive a further 183 aerial bombs, and 23 shell hits from the German Navy. This resulted in casualties of 23 dead and 7 injured. Civilians alarmed by these assaults are portrayed below standing in a bomb crater – note the stiff Eton collars worn by the schoolboys of that day.

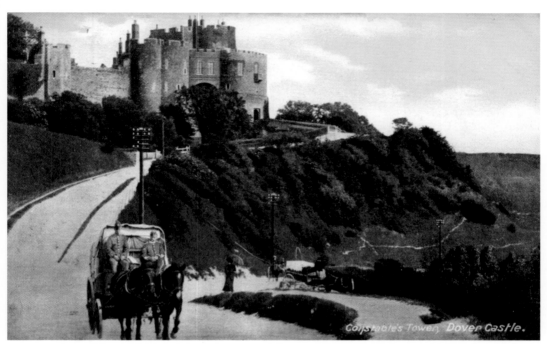

Constable's Tower, Dover Castle.

Visitors to Dover Castle
Now a magnet for tourists, the Castle was once the focus of a large military garrison. Connaught Barracks, north of these snapshots, are closed and awaiting civilian regeneration.

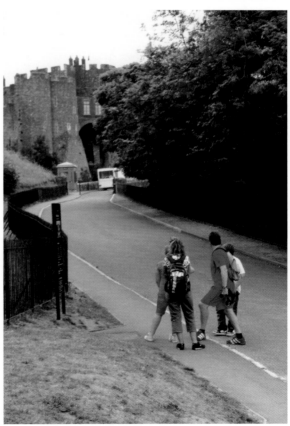

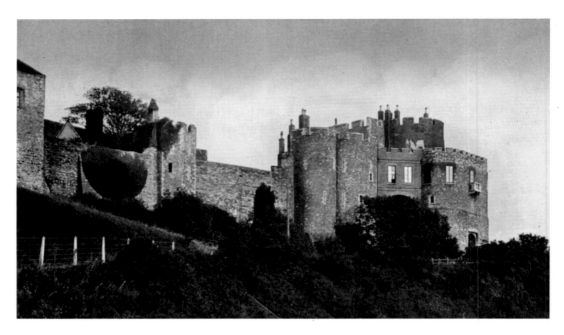

Dover Castle
These old and recent pictures of Dover Castle illustrate the southern wall of concentric defences beyond the main keep.

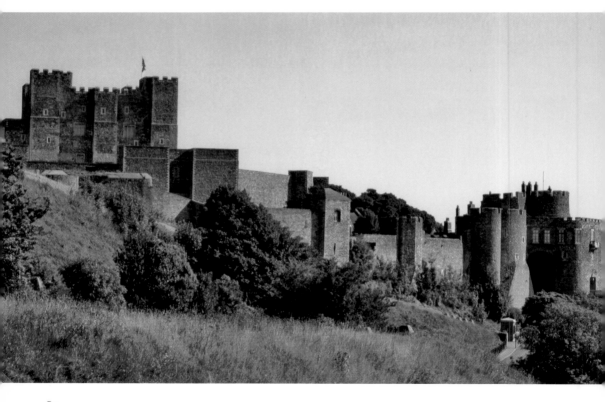

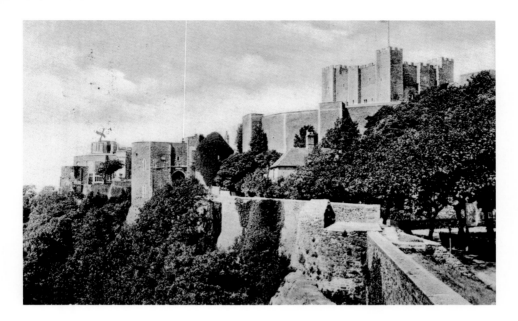

Dover Castle – The Key to England

First built of clay, Dover Castle attracted the unwelcome attention of William the Conqueror and his invasion force. During the reign of Henry II, Maurice the Engineer built its keep. By 1216, much fighting took place here as a consequence of rebel barons inviting Louis VIII of France to take over the crown from King John. However, attacks on the castle were unable to take the keep. Unharmed throughout the Tudor and Stuart dynasties, much strengthening of the defences took place during the Napoleonic Wars. An underground barracks for 2000 troops was constructed at this time. These tunnels and the overall site are owned by English Heritage and run as a major tourist attraction. In 2010, the castle benefited from an expensive and critically acclaimed renovation. Over the years its distinctive presence has brought many film crews to use this dramatic backdrop.

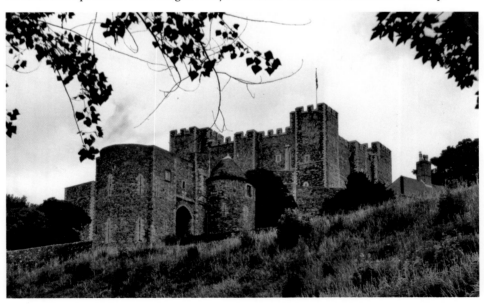

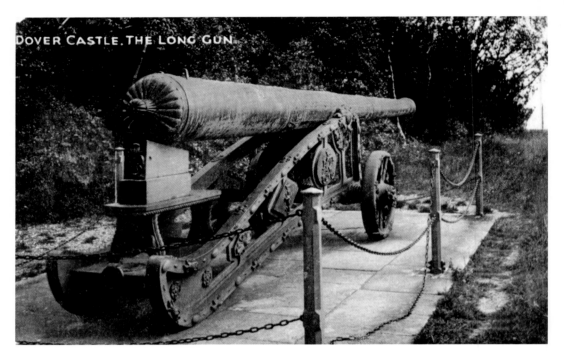

DOVER CASTLE. THE LONG GUN

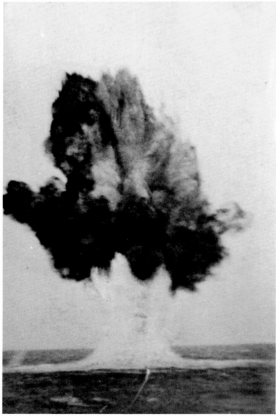

Queen Elizabeth's Pocket Pistol
This long gun perched on the ramparts
of Dover Castle was an ancient 'peace'
offering, presented by the States of
Holland. It has a 24 foot barrel and was
cast in Utrecht, in 1544. Pictured left
is the result of more modern ballistics
when a First World War German shell
exploded off Dover Harbour.

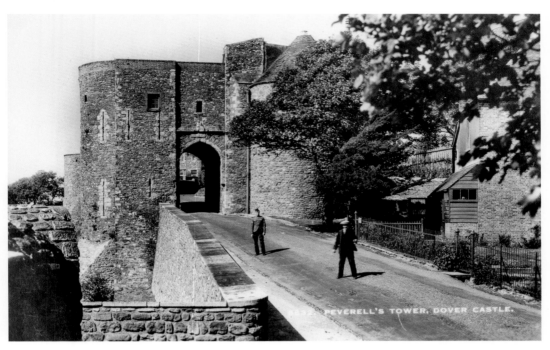

Peverell's Tower

Peverall's Tower forms part of the outer wall of the concentric defences of Dover Castle. It was constructed as part of major works undertaken on the orders of Henry II.

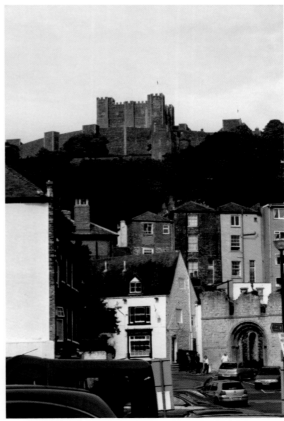

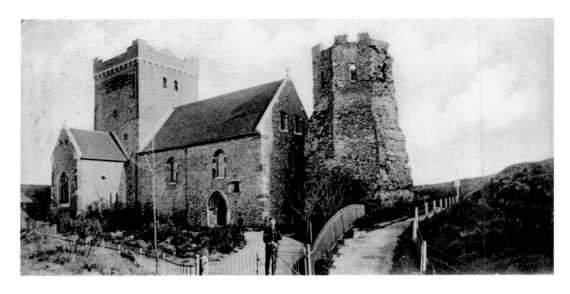

Pharos – Dover Castle

In the second half of the first century AD the Romans built two lighthouses or pharos either side of their harbour to guide shipping. The one on Western Heights is virtually gone but the other at a high point near the castle is relatively well preserved. Its structure has been adapted to become a bell tower for the adjacent Anglo Saxon church. A picture of the more modern, but nonetheless redundant, South Foreland lighthouse is shown below – splendidly painted and maintained by the National Trust.

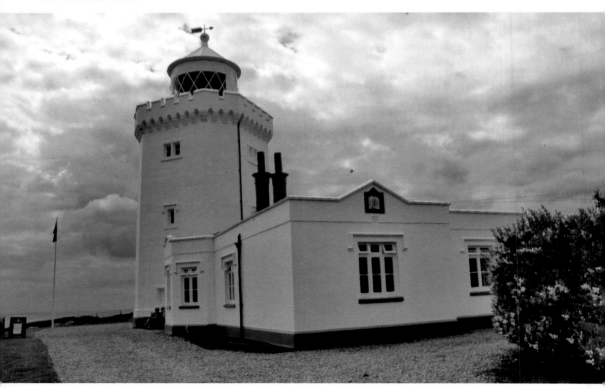

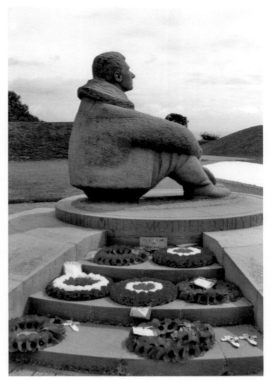

The Brave Few

Hawkinge airfield was at the forefront of the Battle of Britain. Now a museum, it is open to the public where many relics from this vital battle for air supremacy over south-east England are displayed. To salute the brave pilots who gave their lives in this conflict a moving memorial looks out over the Channel at Capel le Ferne. The wreaths around the statue were laid to mark the 70th anniversary of this epic battle.

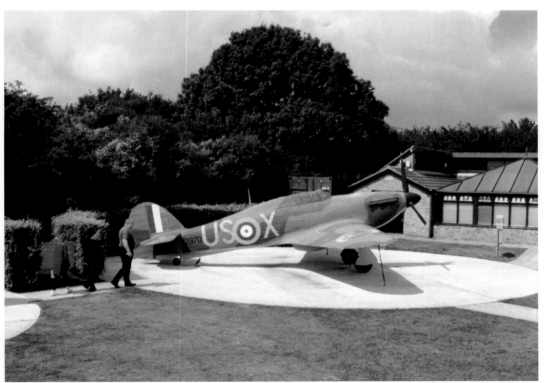

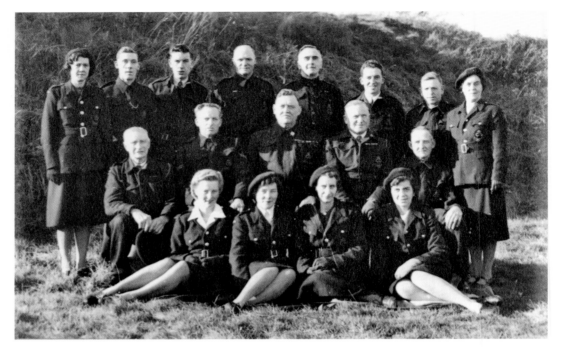

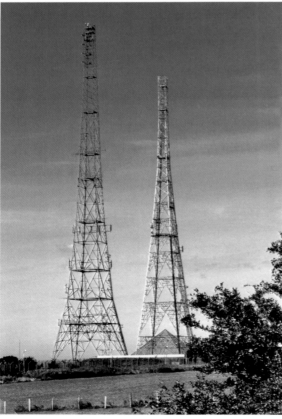

Air Raid Wardens

Dover was protected from aerial bombardment by barrage balloons and anti-aircraft guns. However, many bombs landed together with heavy shells from large coastal guns stationed in France. Above is a civil defence team of Dover air raid wardens who must have been some of the busiest in the country. RDF or radar, as it became known, greatly assisted in the detection of enemy aircraft attacks. The radar towers at Swingate are the last surviving from the Second World War, and are now being dismantled.

Kent Coalfield

In 1890 coal was discovered accidentally, while early work on a channel tunnel was in progress near Shakespeare Cliff. Eventually Kent Coalfield grew to comprise four economically viable pits. Snowdown was the deepest of these and its atmosphere was so hot that the workforce nicknamed it Dante's Inferno. Opened in 1908, it lasted until 1986. Output from the Kent Coalfield went to Richborough Power Station where the statue was originally placed before closure. It has been moved to Dover seafront near offices previously used by the Coal Board. Meanwhile the derelict buildings of Snowdown Colliery are eerily quiet after a workforce, which in 1945 numbered 1,876, left to retire or seek alternative employment.

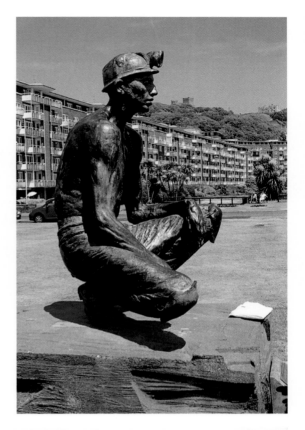

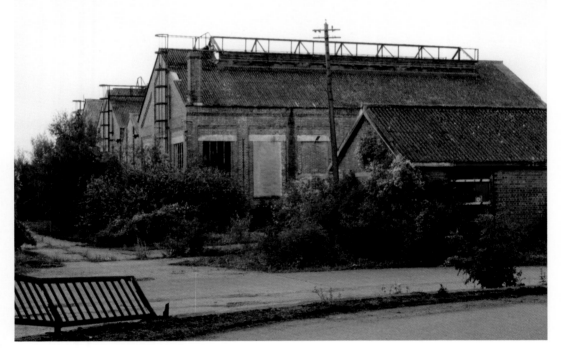

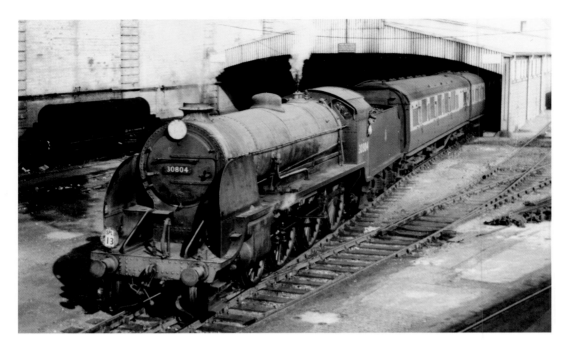

Kearsney Railway Station

Kearsney Station was opened by the London, Chatham and Dover Railway in 1862. It serves the parishes of Kearsney and River. In fact the community of Kearsney largely grew up around the Railway Bell Hotel which was on the Dover to London road. Photographed in 1955, above is one of the last steam trains on this line.

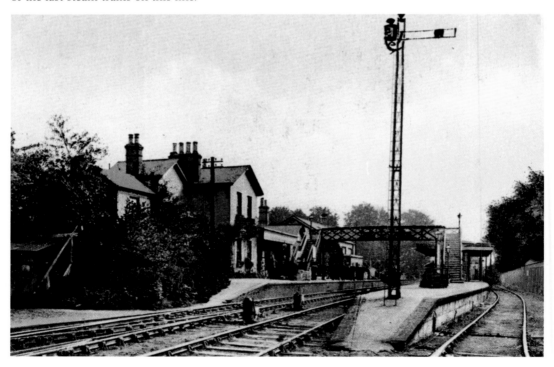

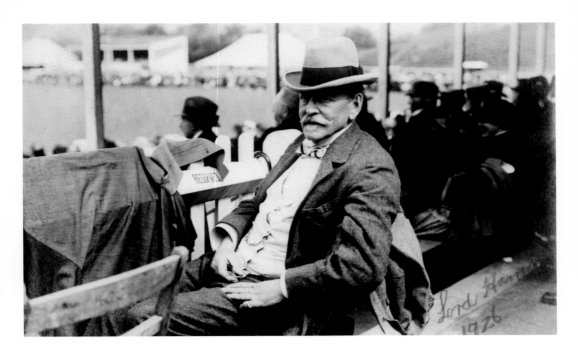

Crabble Athletic Ground – River, Dover

This ground originated as a sports complex in 1896 and was the brainchild of local businessmen. At first cricketers had priority over the use of the pitch, but an upper field was later developed for football. The word Crabble derives from the Old English *crabba hol* – a crab hole. It accurately describes its position cut into a bank. The lower cricket pitch, illustrated below, was used by Kent County Cricket Club as one of its home venues from 1907 to 1976. At one of the matches played there is spectator Lord Harris. Resplendent in bow tie and homburg hat, he was famous for being the instigator of the Ashes series with Australia. An exceptional England captain he resided in Kent at Belmont near Faversham.

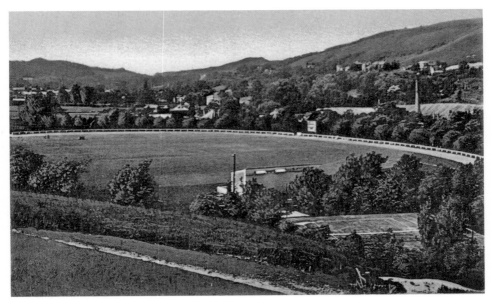

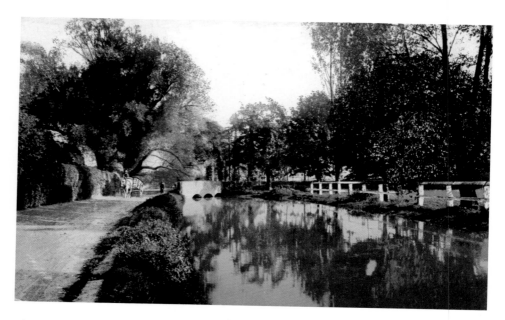

River Dour

It is to the tranquil, translucent, flowing waters of the Dour that Dover largely owes its existence. Early evidence of civilisation is the renowned Bronze Age boat which was excavated and preserved some three thousand years after its useful lifetime. The Romans based their fleet here – protected by the high flanking hills. However, by Norman times the natural harbour had silted up and docks were moved westwards. England's first recorded mill was developed here in AD 762. It was the first of many to follow, including eight corn mills and five paper mills. Other industry located here to benefit from the waters was an iron foundry, saw mills and a tannery.

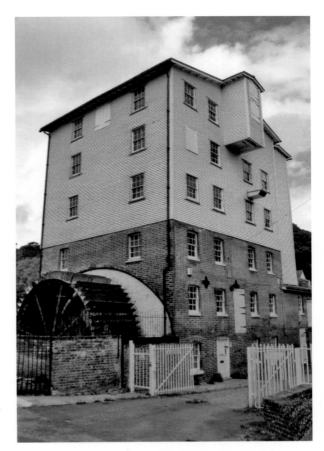

Crabble Mill

Crabble Mill was built in 1812 to produce flour for a growing influx of military personnel involved in the Napoleonic wars. It was one of some twelve water mills located on the River Dour. Having been made redundant by steam power it is now restored to working order and a popular tourist attraction.

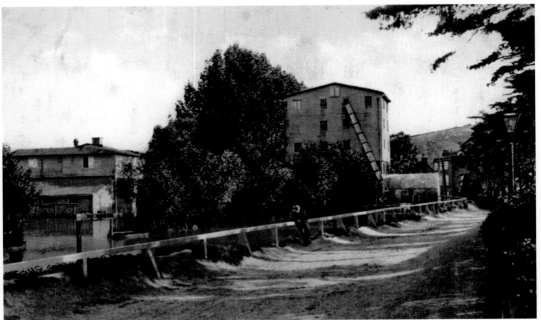

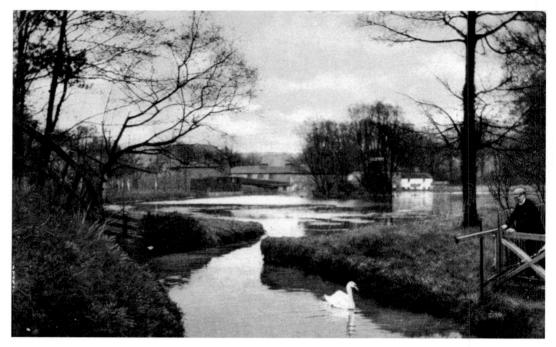

Kearsney

Situated on the Dour, Kearsney has become a suburb of Dover. It was once, however, a separate hamlet. Its name is derived from the Saxon word for a place where watercress grows. The so called Abbey was a large residence constructed from old parts of Dover's medieval fortifications. After use by the army in the Second World War, the mansion was demolished, apart from its billiard room which currently serves as a café. The famous South African boarding school takes its name from this quiet corner of Dover.

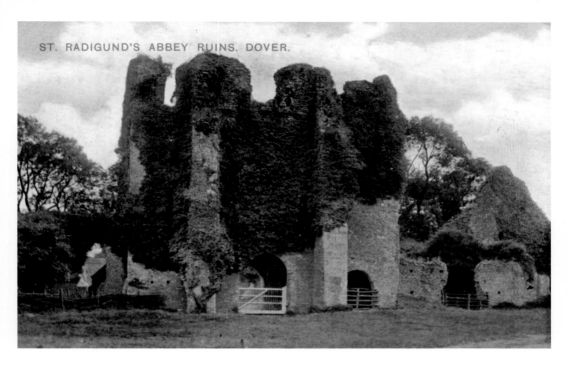

ST. RADIGUND'S ABBEY RUINS, DOVER.

St Radigund's Abbey Ruins

In the late twelfth century these ruins were occupied by French monks. Now the adjoining farm offers self catering holiday units to rent. The demise of this religious community was completed when Henry VII recycled its masonry for strengthening nearby coastal fortifications.

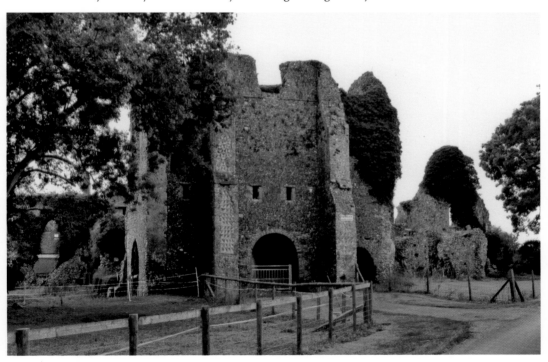

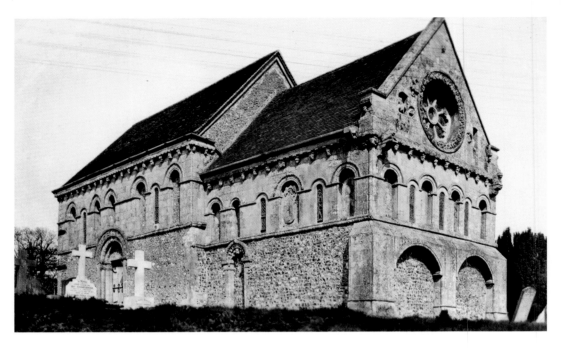

Barfreston Church

A unique gem tucked away in countryside near Dover, this church is partly constructed of Caen stone. This material has been richly carved and shows a degree of wealth usually associated with the de Port family from Dover Castle. Without a tower, the congregation is summoned to worship with a bell hung from a yew tree.

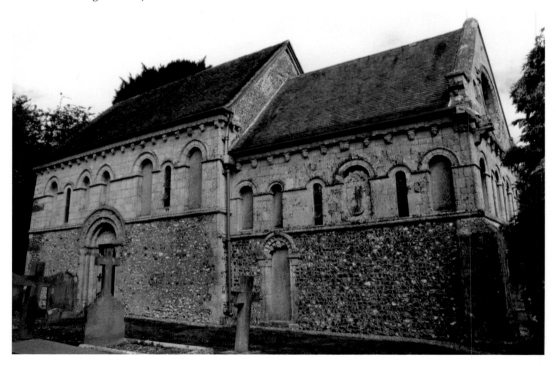

At DOVER.

I'VE CLICKED.

Postcard Mania

This volume ends with reproduced illustrations of two apposite and mildly humorous seaside postcards. A hundred years ago they were a principal medium of communication used with equal frequency as email is today. Fortunately for modern historians, the popular topographical ones were avidly collected and as such have provided this book with a window into how life was in Dover some hundred years ago.

DOVER.

We're leaving here, and we didn't want to do it.

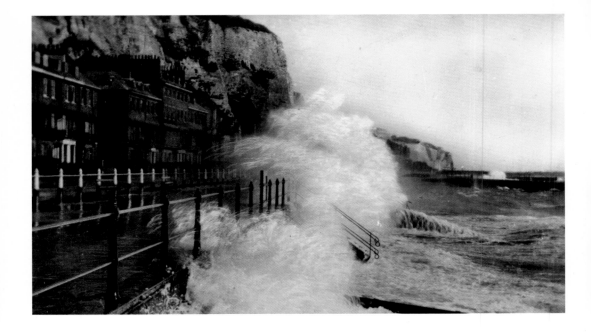

Dover Beach, a poem by Mathew Arnold who honeymooned at Dover starts with the lines ...

The Sea is calm to-night
The tide is full, the moon lies fair
Upon the straits, – on the French coast the light
Gleams and is gone; the cliffs of Dover stand

Later this poem was trivialised in *The Dover Bitch* by Anthony Hecht a more contemporary poet who used the lines ...

So there stood Mathew Arnold and this girl
With the cliffs of England crumbling away behind them

Acknowledgements

Thanks go to Jocelyn Watson, Neels Bornman, Chris Rapley, John Rendle, Tony Ricksons and Sittingbourne library.